ARTISTIC PLANTS & FLOWERS

Edited by

M. P. Verneuil

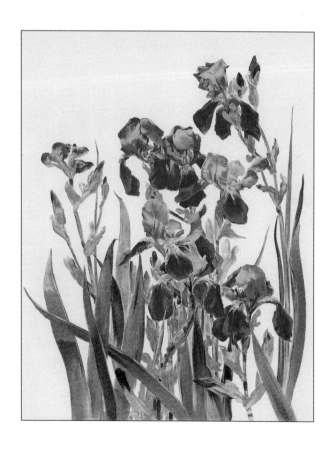

Dover Publications, Inc.
Mineola, New York

Bibliographical Note

This Dover edition, first published in 2009, is a new selection of 120 plates from *Encyclopédie artistique et documentaire de la plante*, originally published as a four-volume set by the Librairie Centrale des Beaux-Arts, Paris, in 1904–08.

DOVER *Pictorial Archive* SERIES

Library of Congress Cataloging-in-Publication Data

Encyclopédie artistique et documentaire de la plante. Selections.
 Artistic plants and flowers / edited by M. P. Verneuil.
 p. cm. — (Dover pictorial archive series)
 "This Dover edition, first published in 2009, is a new selection of 120 plates from Encyclopédie artistique et documentaire de la plante, originally published as a four-volume set by the Librairie Centrale des Beaux-Arts, Paris, in 1904–08.
 ISBN-13: 978-0-486-47251-5
 ISBN-10: 0-486-47251-5
 1. Decoration and ornament—Plant forms—Pictorial works. I. Verneuil, M. P. (Maurice Pillard), 1869–1942. II. Title.

NK1560.E53 2009
745.4—dc22

2009018129

Manufactured in the United States by Courier Corporation
47251501
www.doverpublications.com

Note

Depicting the exquisite beauty and wide variety of lush flowers and plants in full bloom, the present volume reproduces, in full color, a selection of 120 plates from a rare four-volume French publication originally published in 1904–08. This spectacular work showcases the graceful, sinuous lines of the Art Nouveau style. A leading figure in the Art Nouveau movement, M. P. Verneuil was enthralled with the decorative potential of flowers and floral arrangements, and this collection features elegant renderings of blooms by such popular artists of the early twentieth century as M. Méheut, Alphonse Mucha, and other noted illustrators.

Glorious images of blossoms and flowers have been carefully selected and meticulously reproduced to provide a rich treasury of botanical illustration. An assortment of familiar flowers such as lilacs, roses, dahlias, poppies, and tulips are represented in exceptionally fine detail with realistic, vibrant colors. Contrasted with these gorgeous botanical illustrations are precise and expressive black-and-white renderings of the same flower. These illustrations are arranged in alphabetical order by the common name of each flower.

List of Plates

THE PLATES

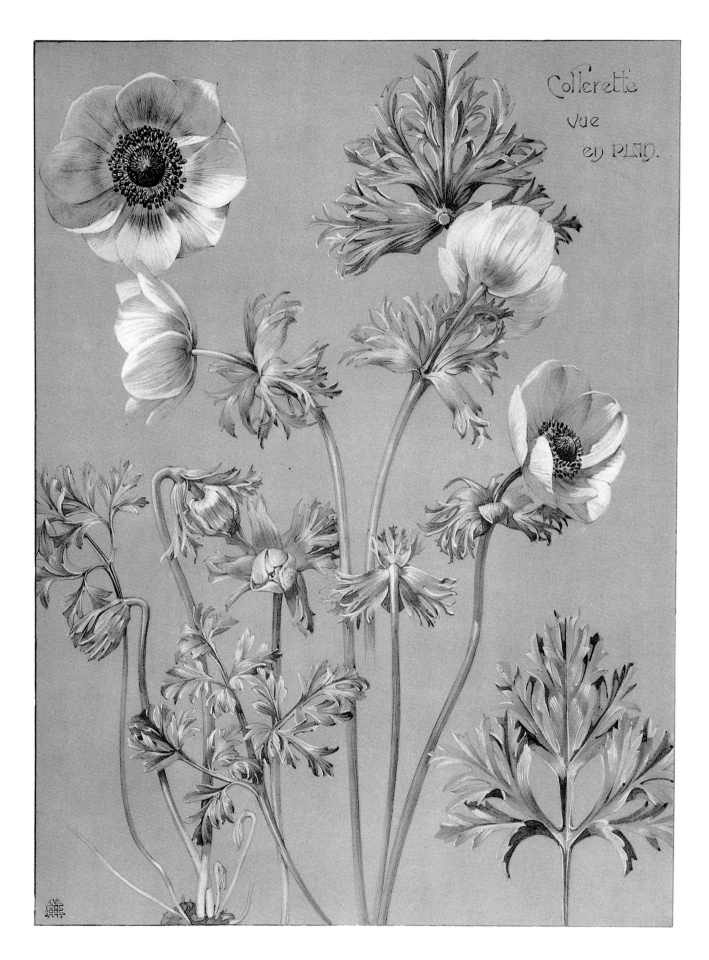

Collerette
vue
en PLIN.

2 Anemone

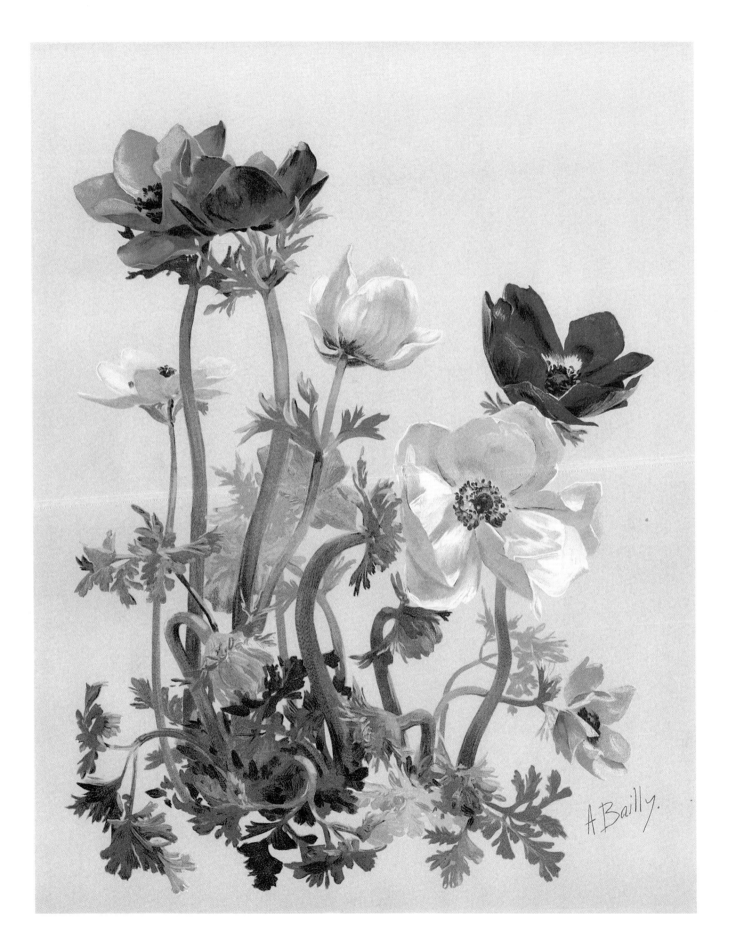

Anemone 3

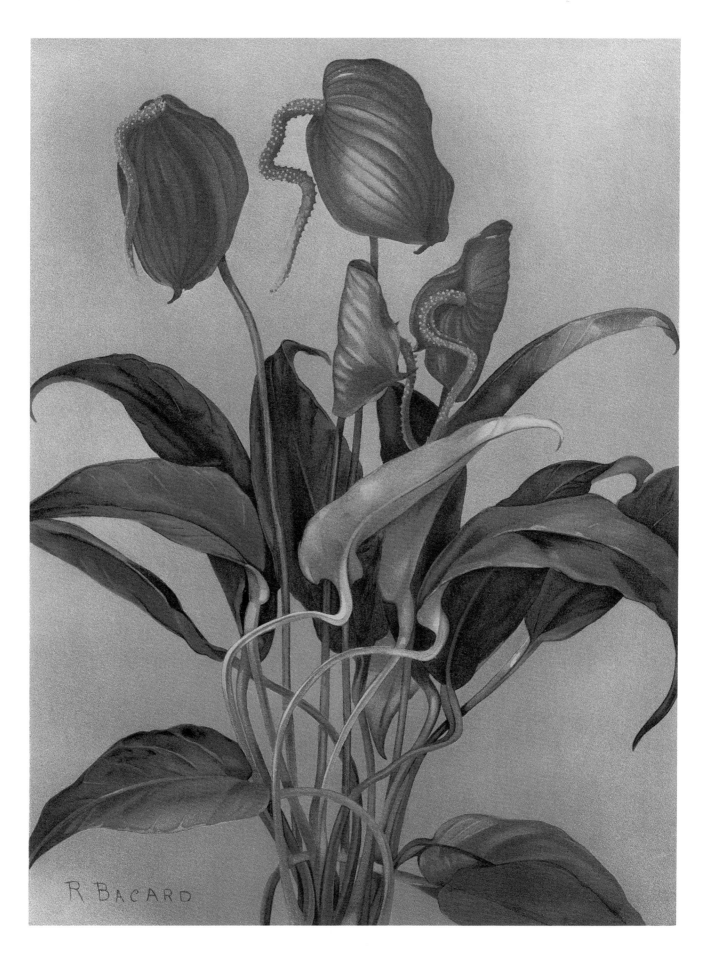

4 Anthurium

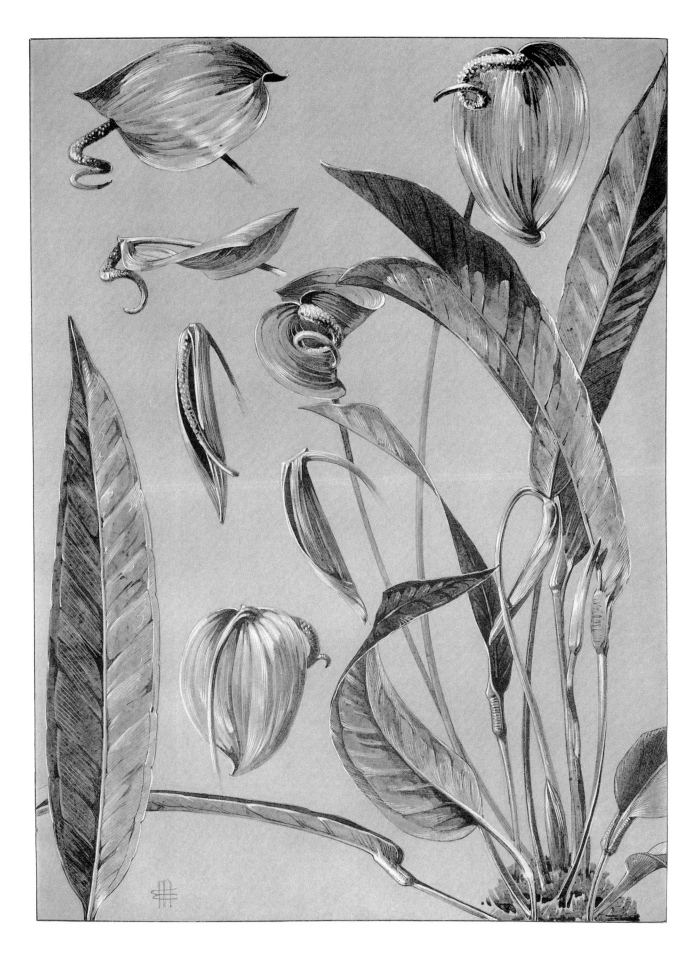

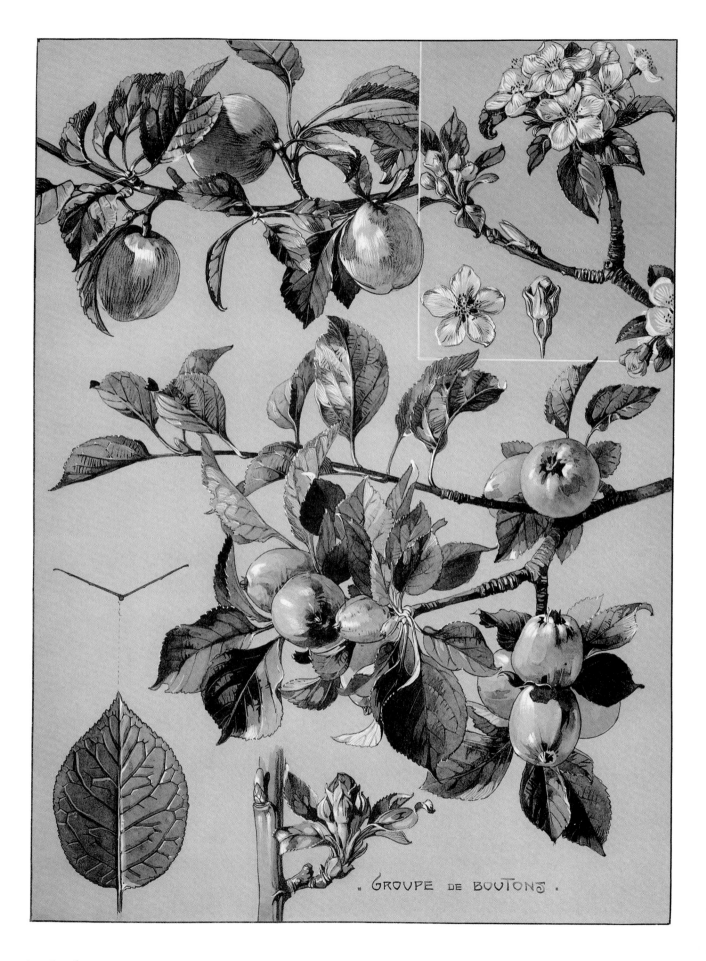

. GROUPE DE BOUTONS .

6 Apple

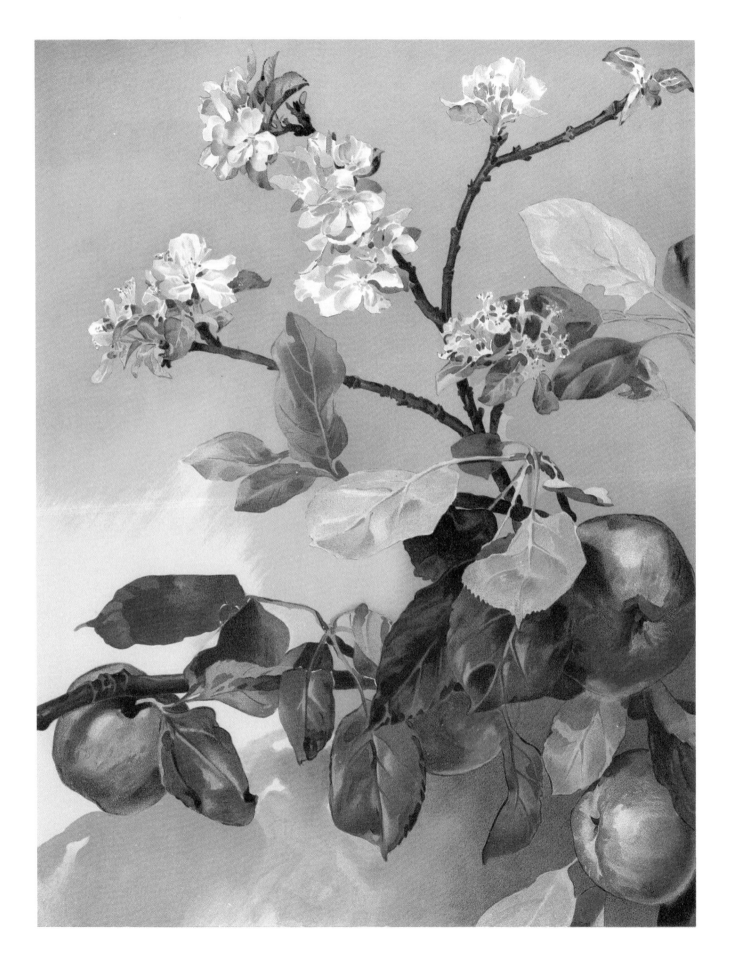

Apple 7

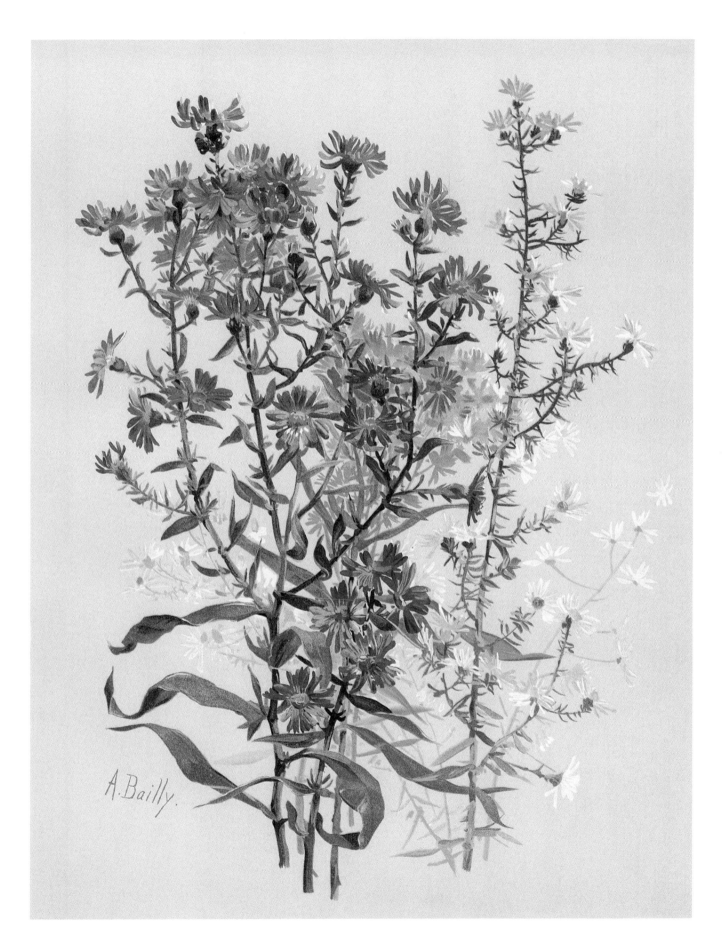

A. Bailly.

8 Aster

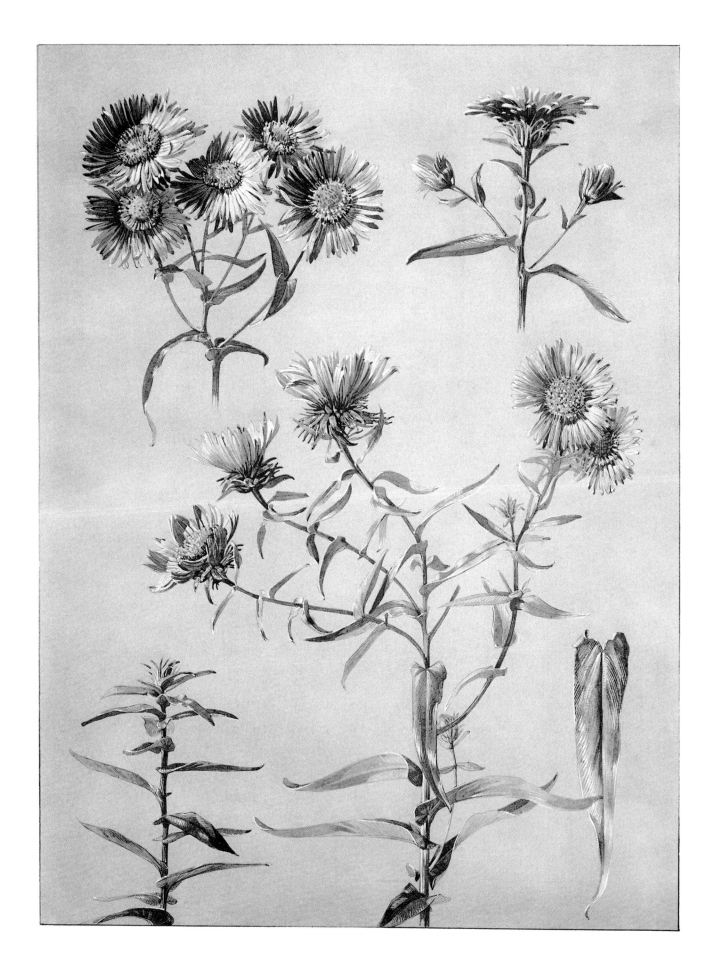

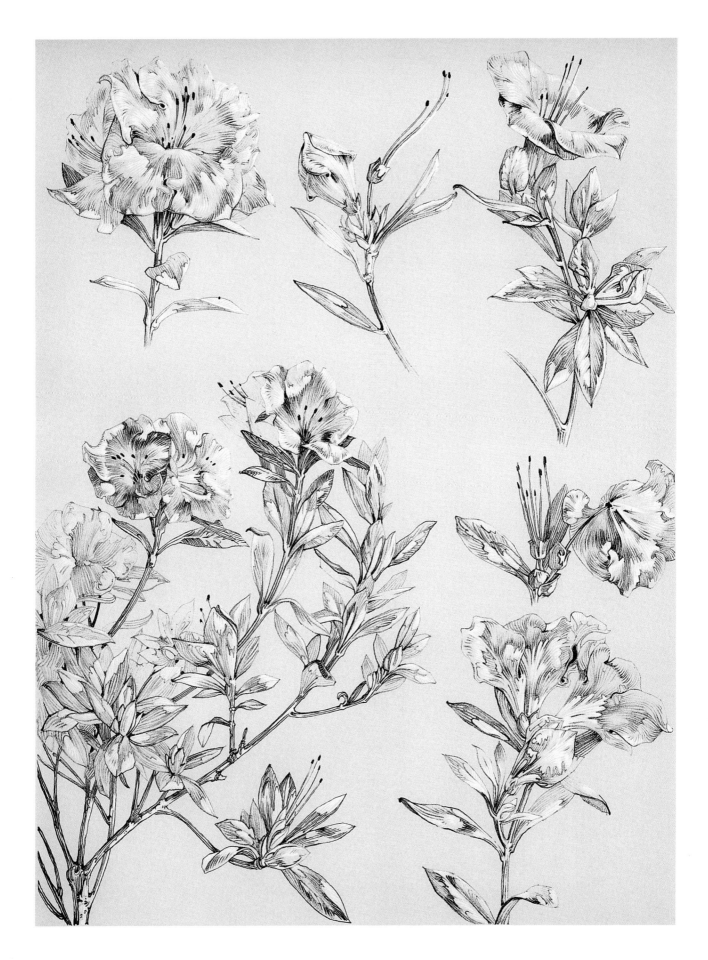

10 Azalea

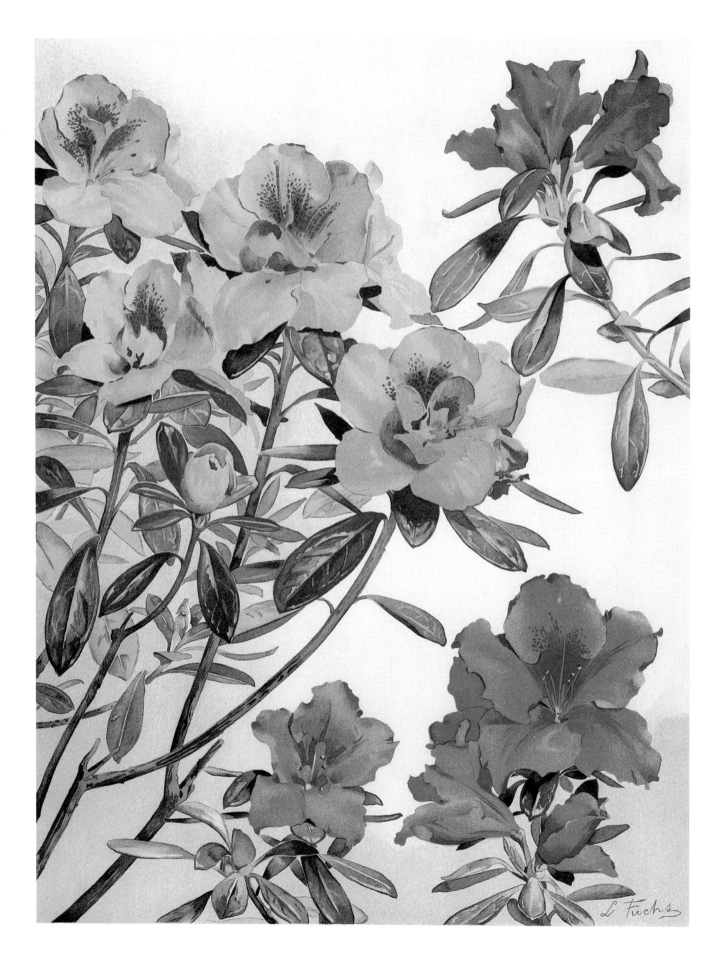

Azalea II

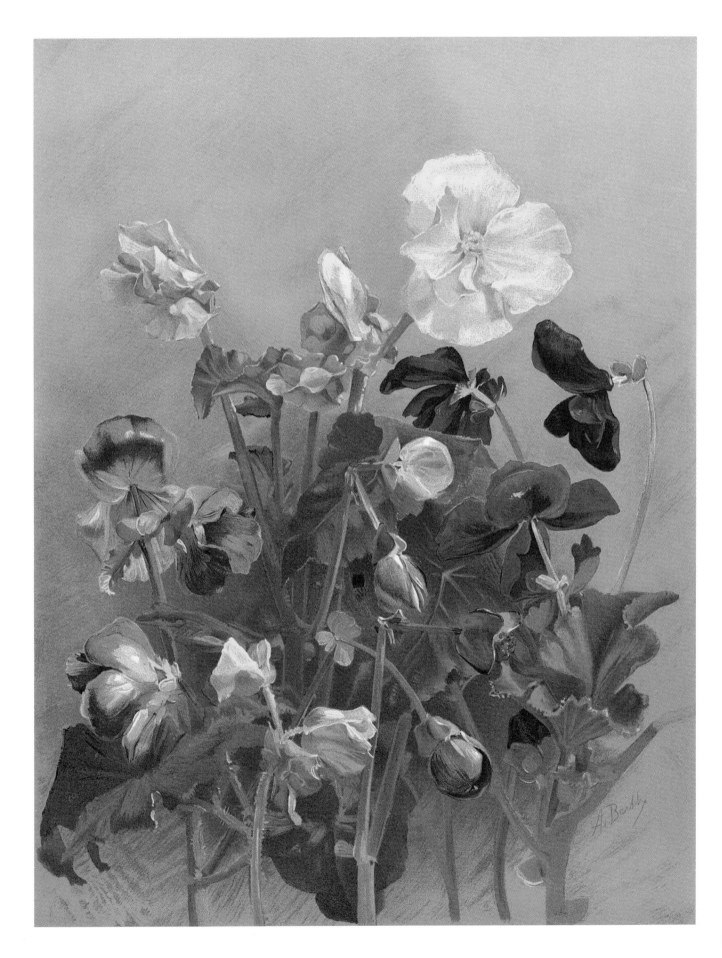

12 Begonia

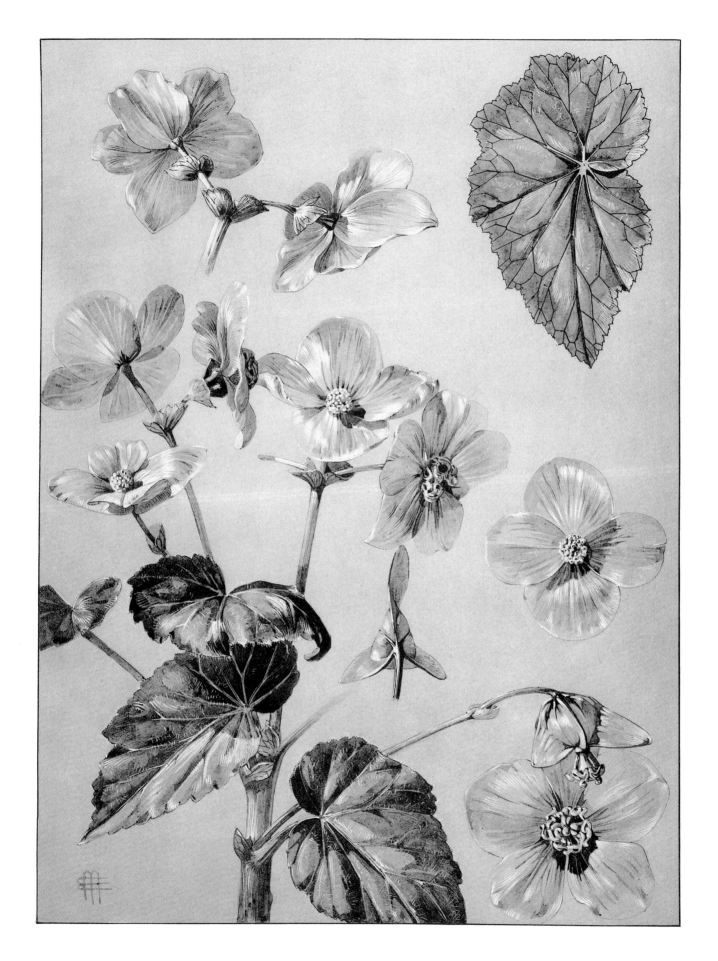

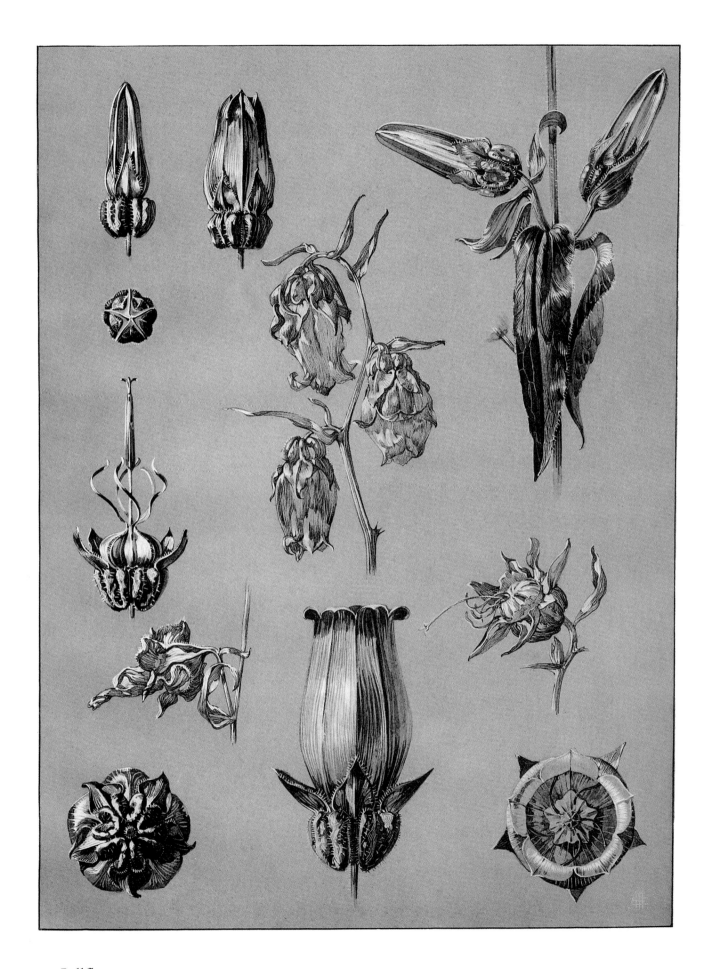

14 Bellflower

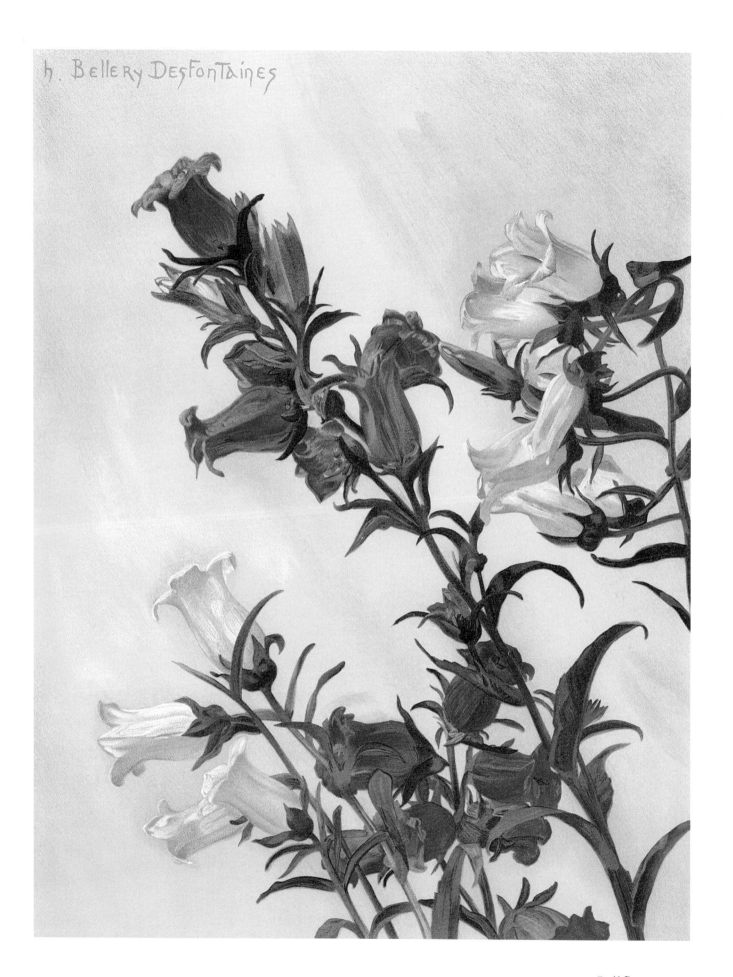

h. Bellery Desfontaines

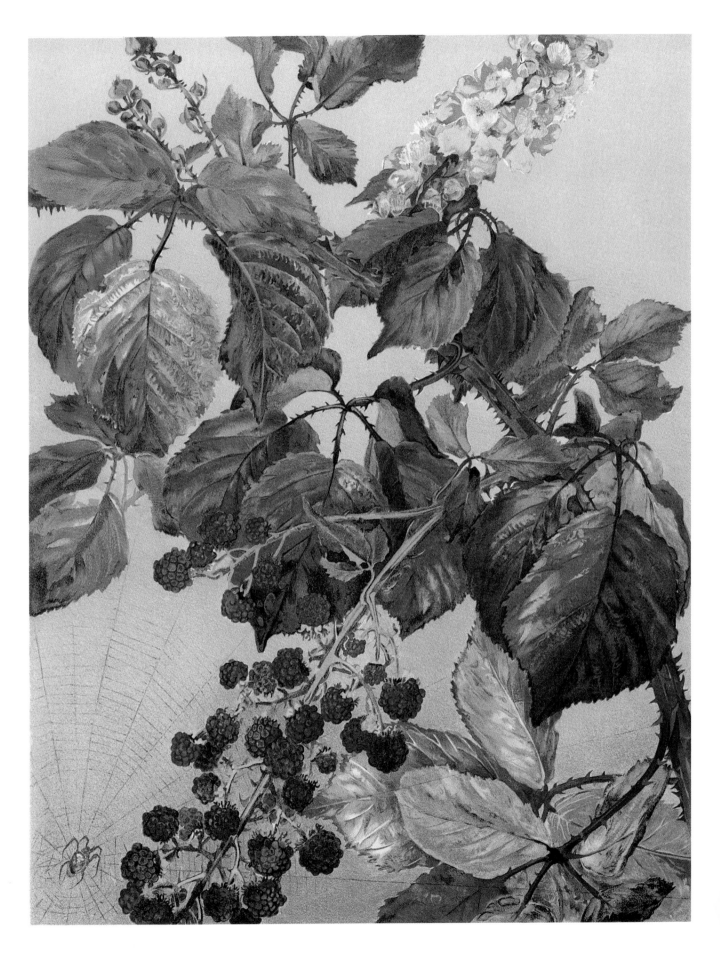

16 Blackberry

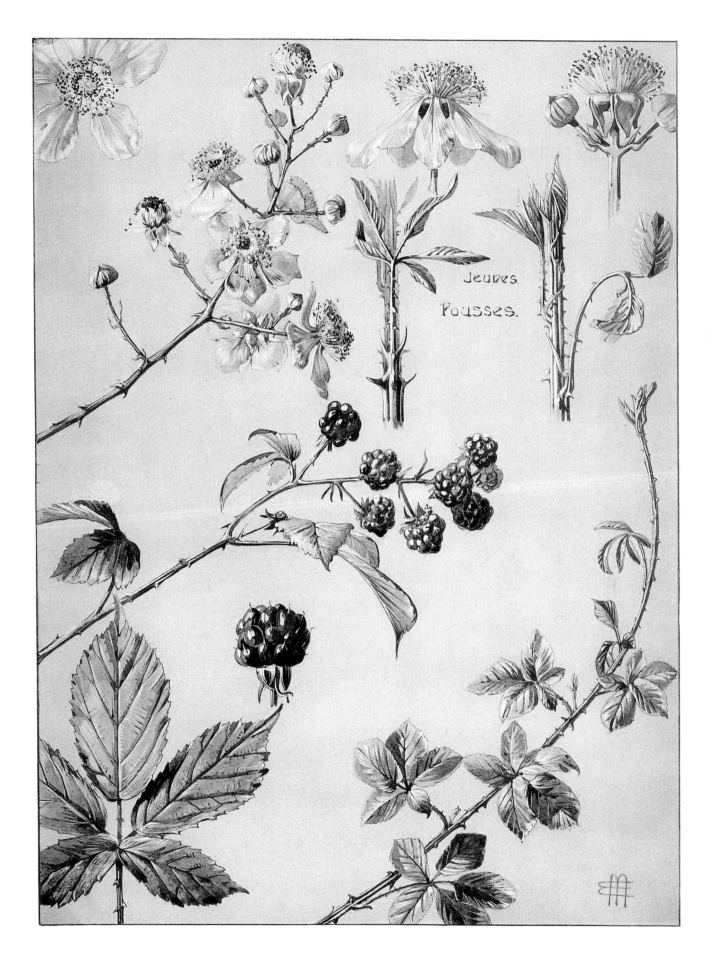

Jeunes.

Pousses.

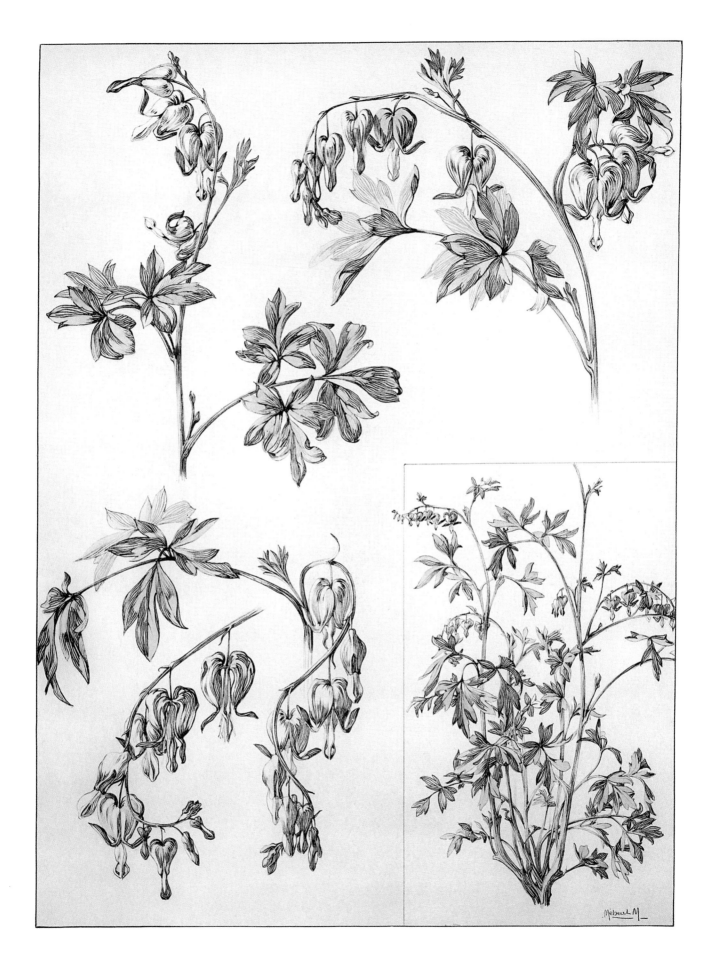

18 Bleeding heart

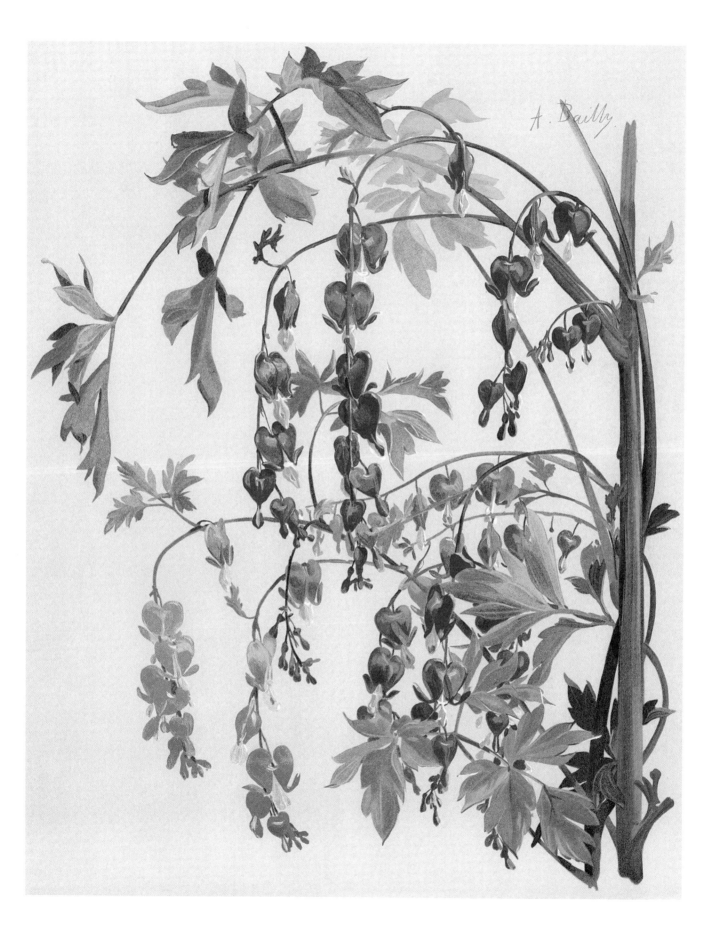

A. Bailly.

Bleeding heart 19

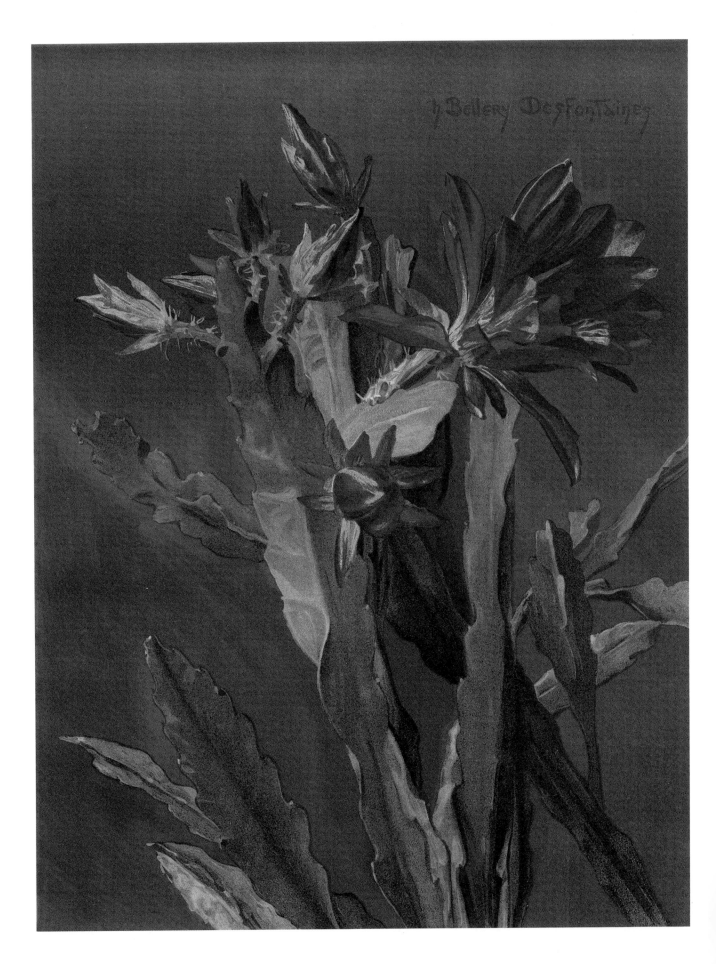

20 Cactus

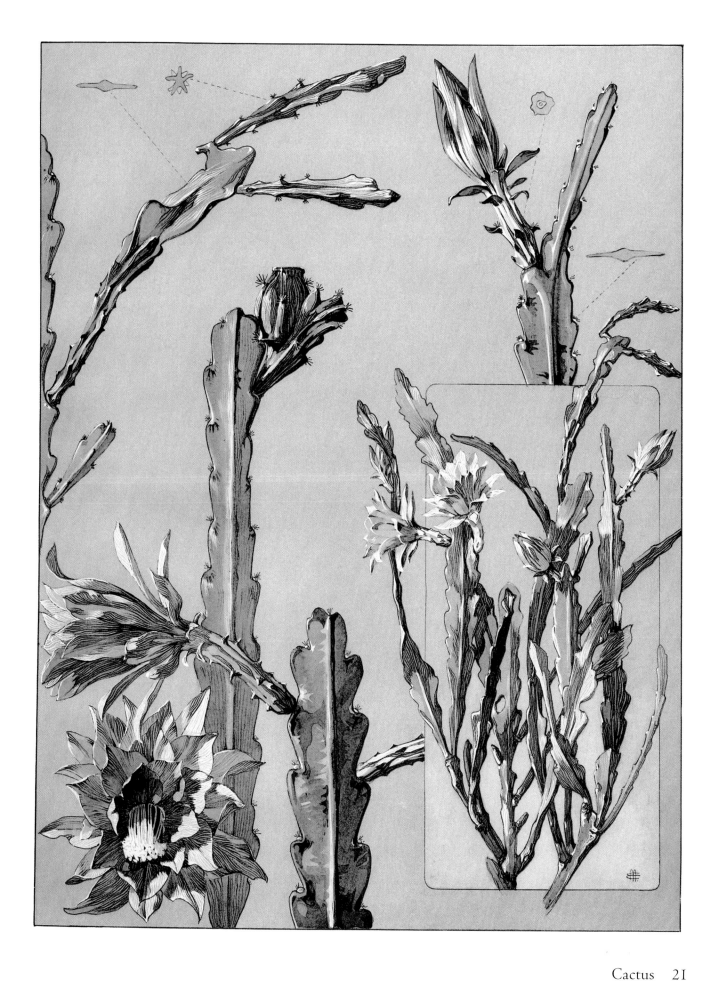

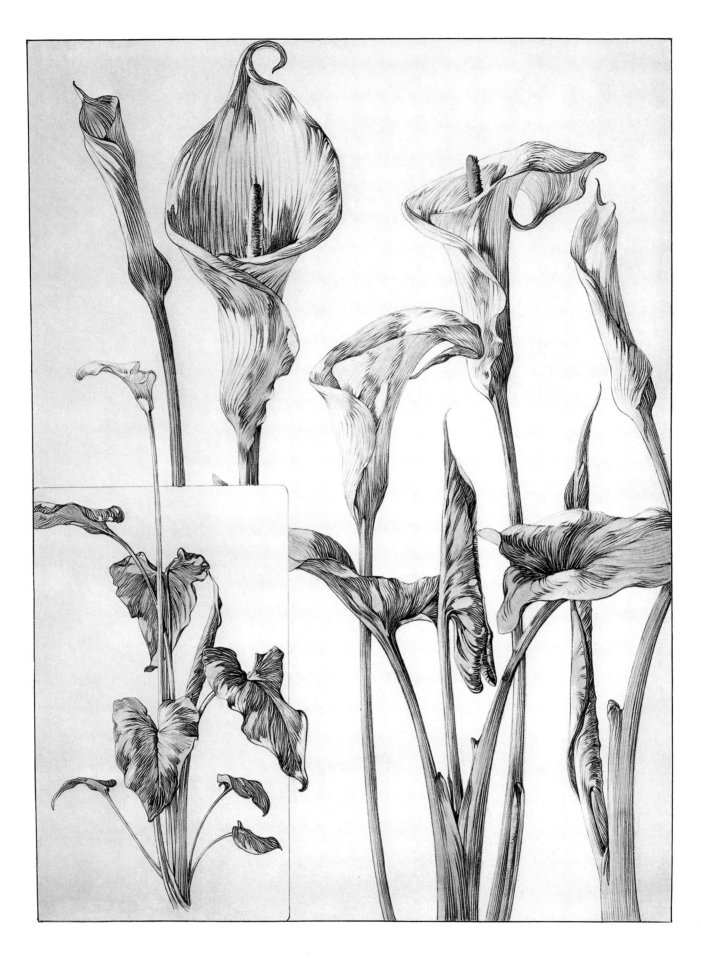

22 Calla lily

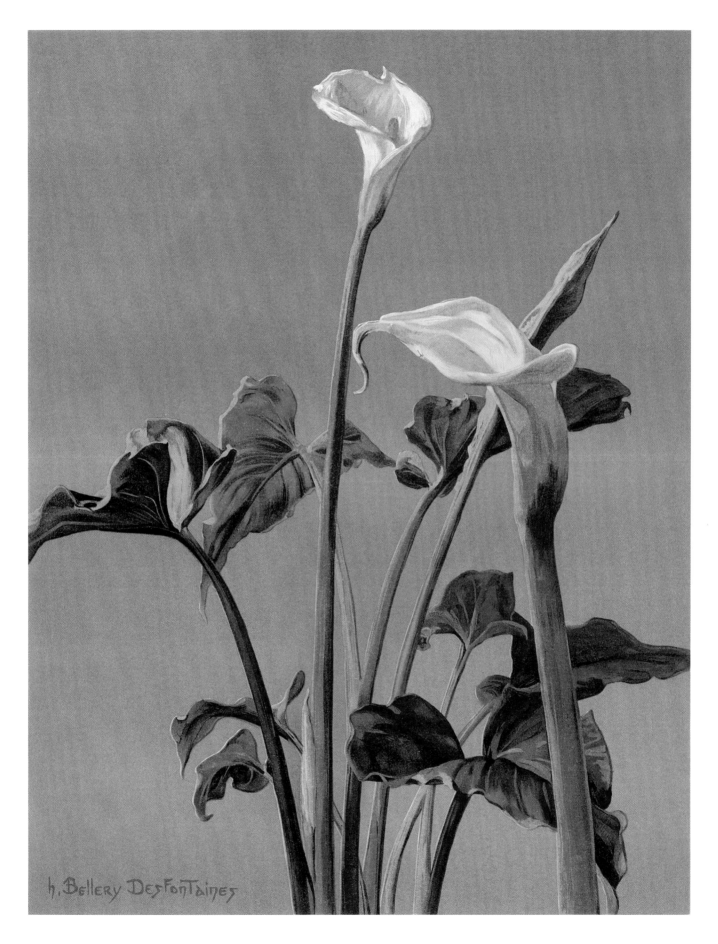

h. Bellery Desfontaines

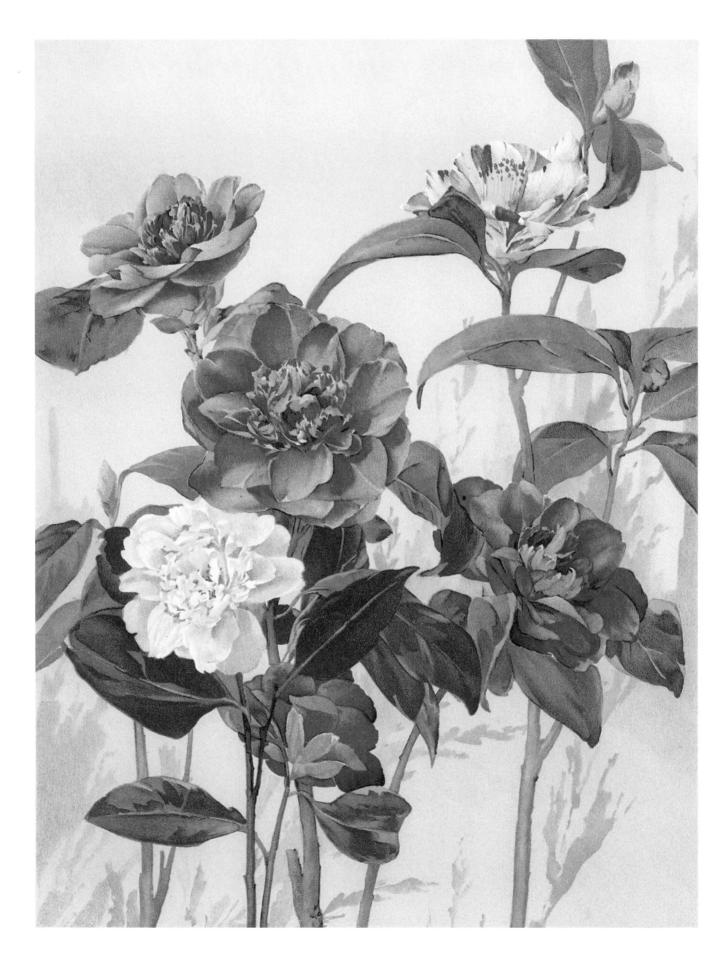

24 Camellia

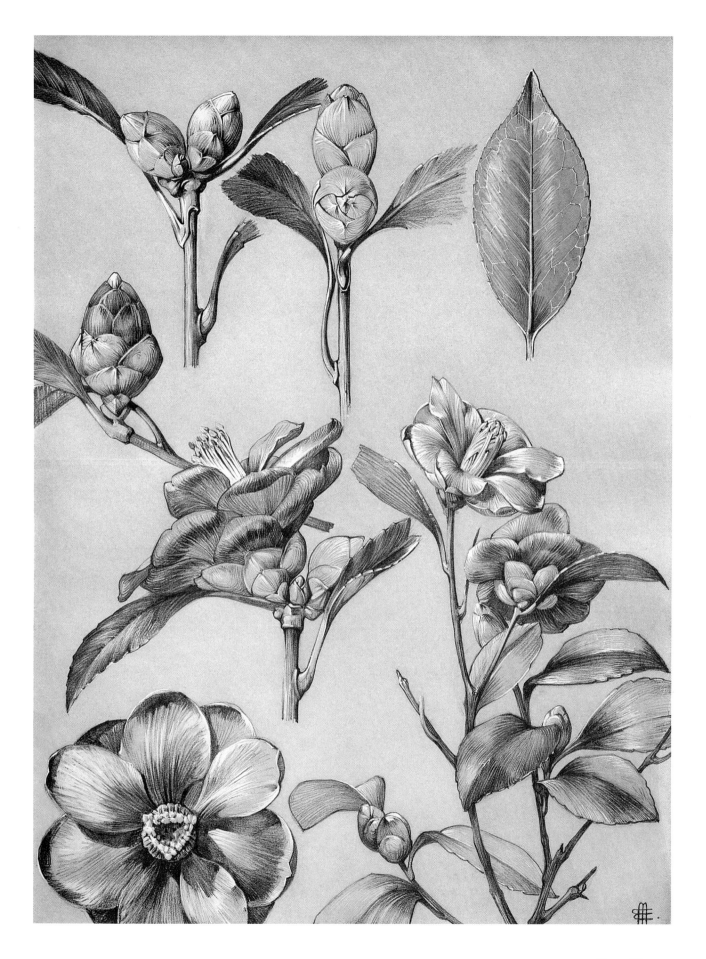

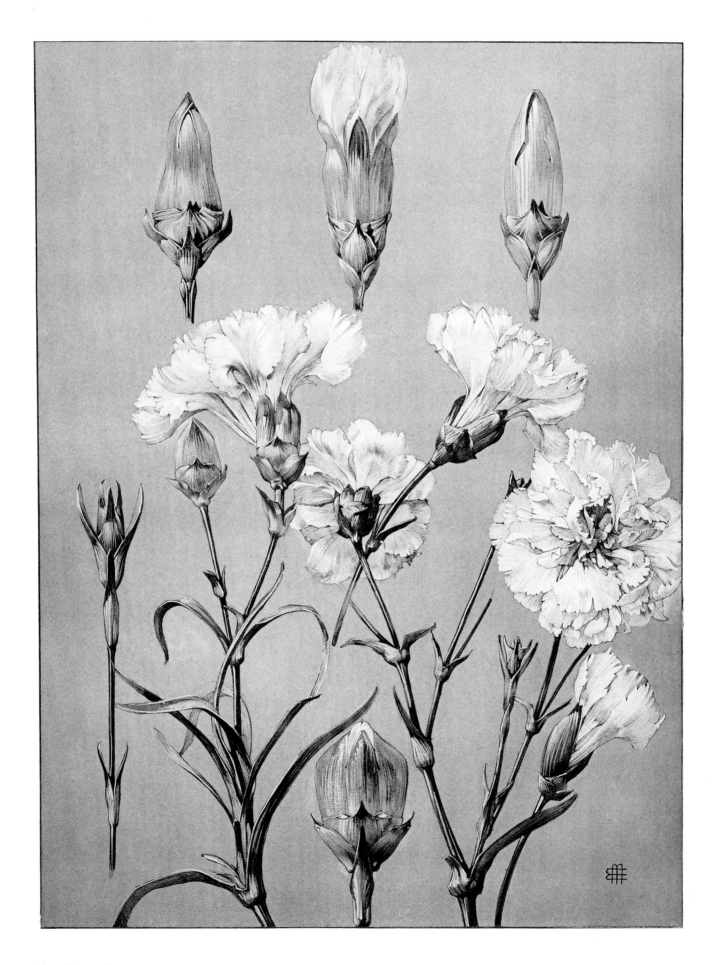

26 Carnation

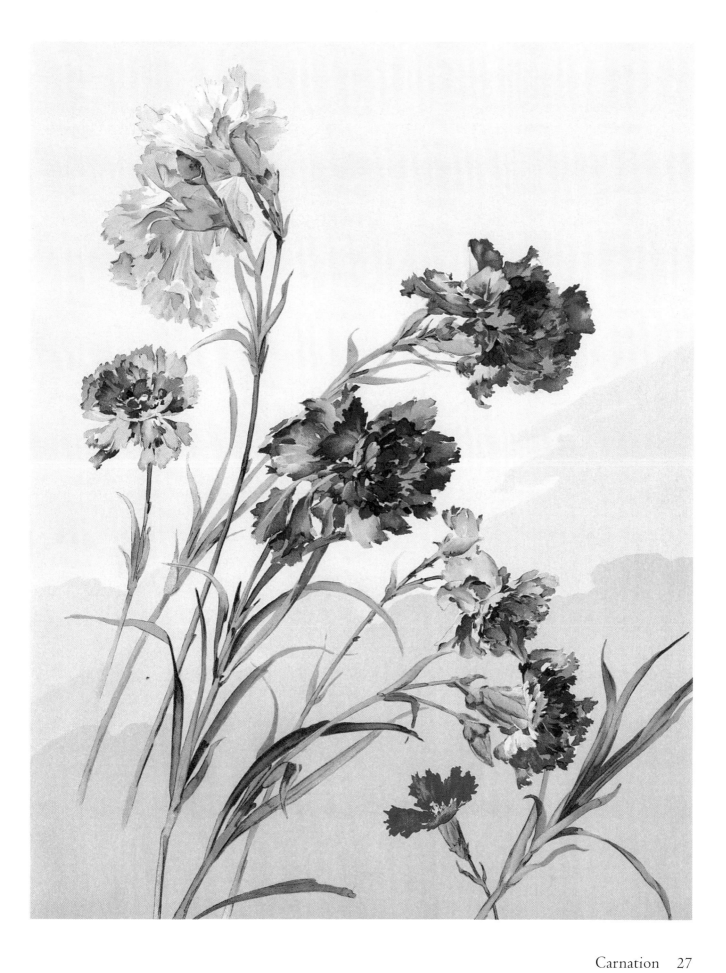

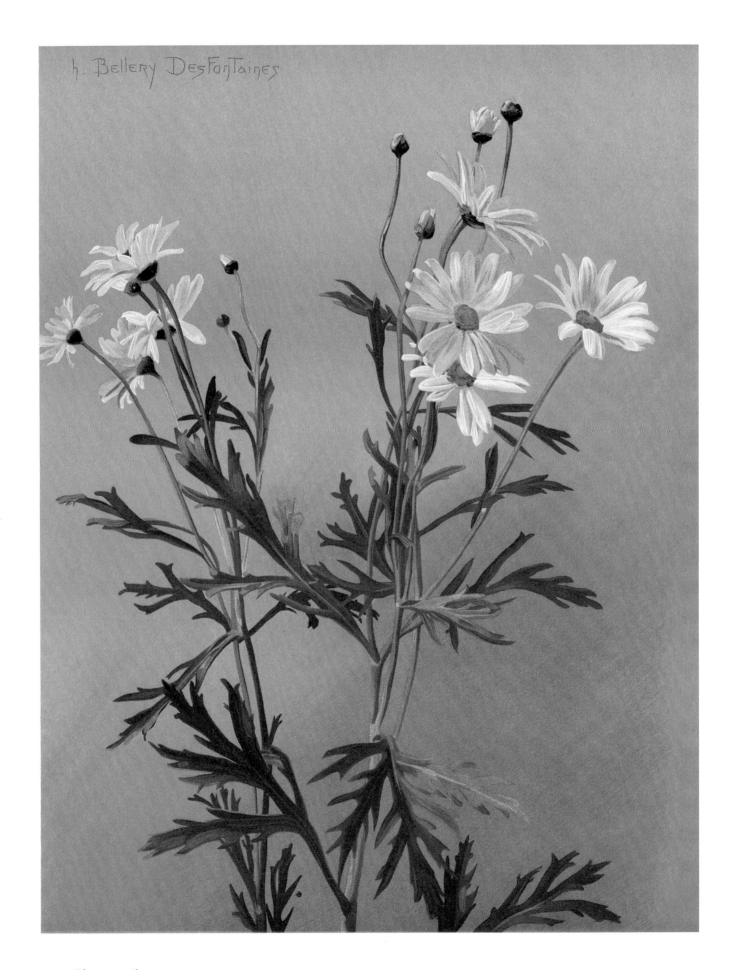

h. Bellery DesFontaines

28 Chamomile

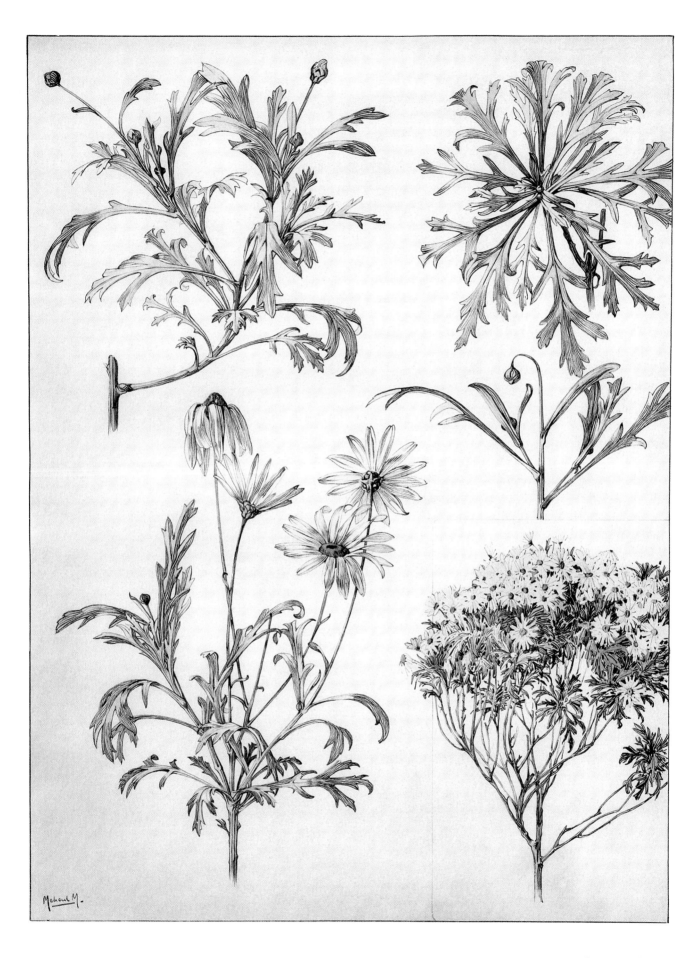

Chamomile 29

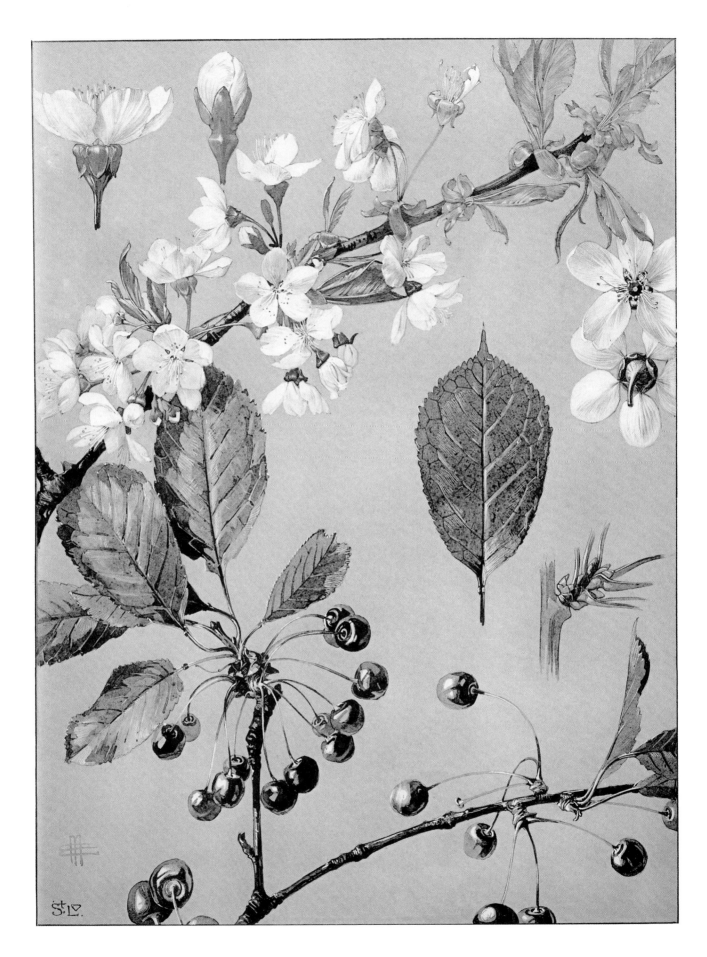

30 Cherry

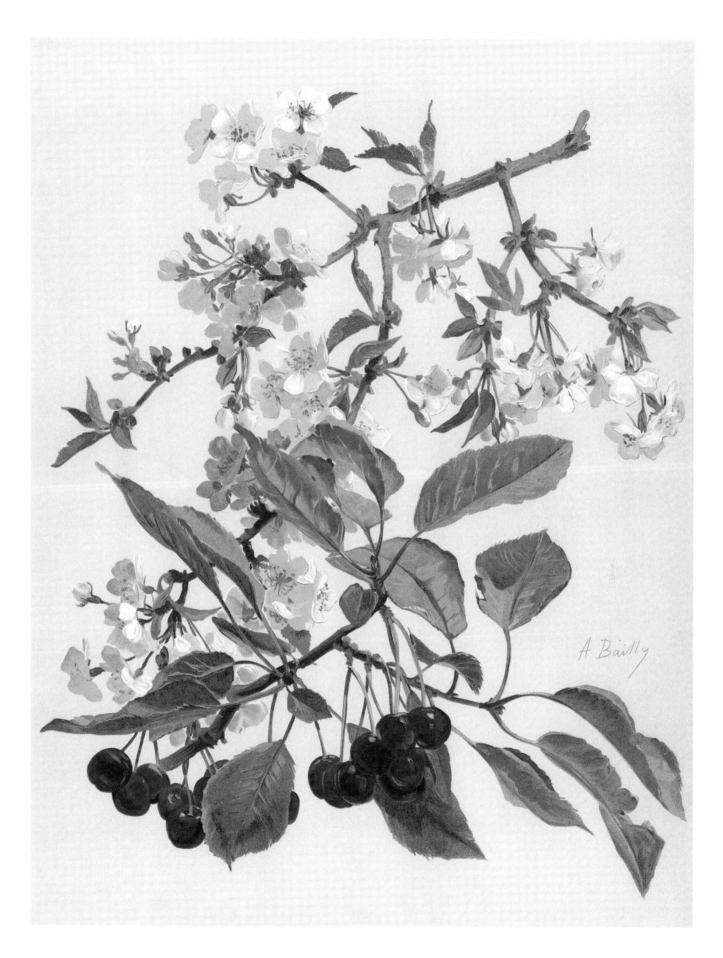

A Bailly

Cherry 31

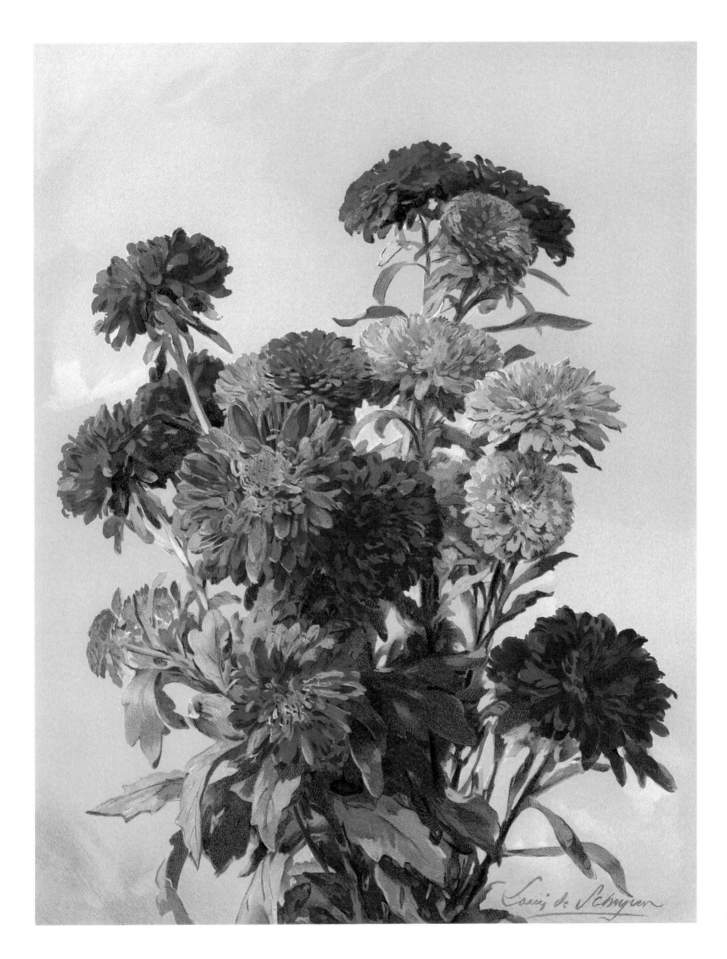

32 China aster

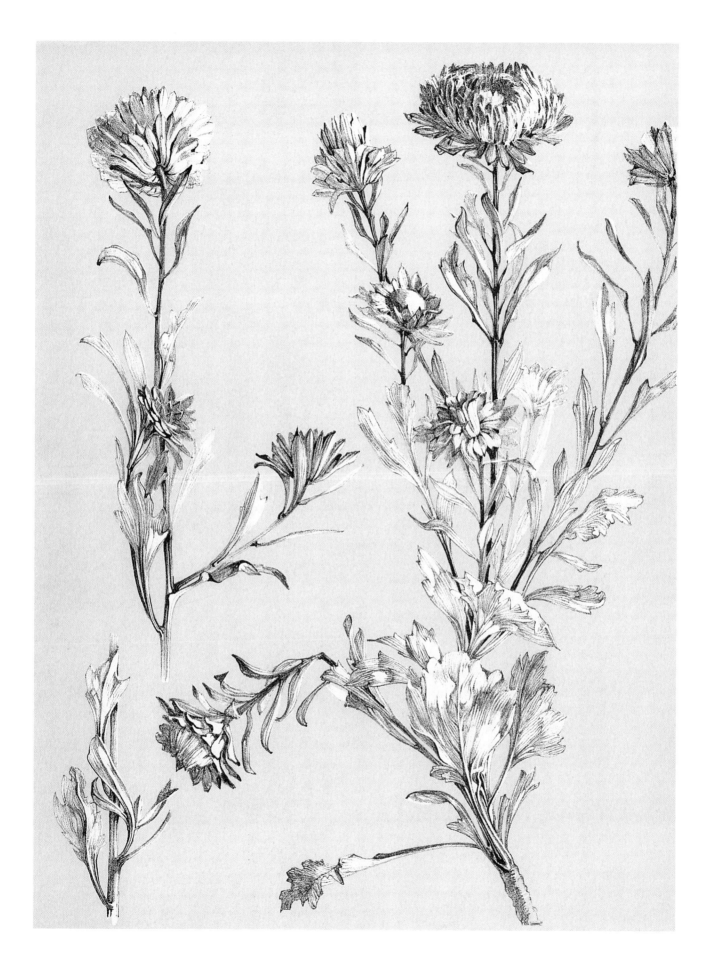

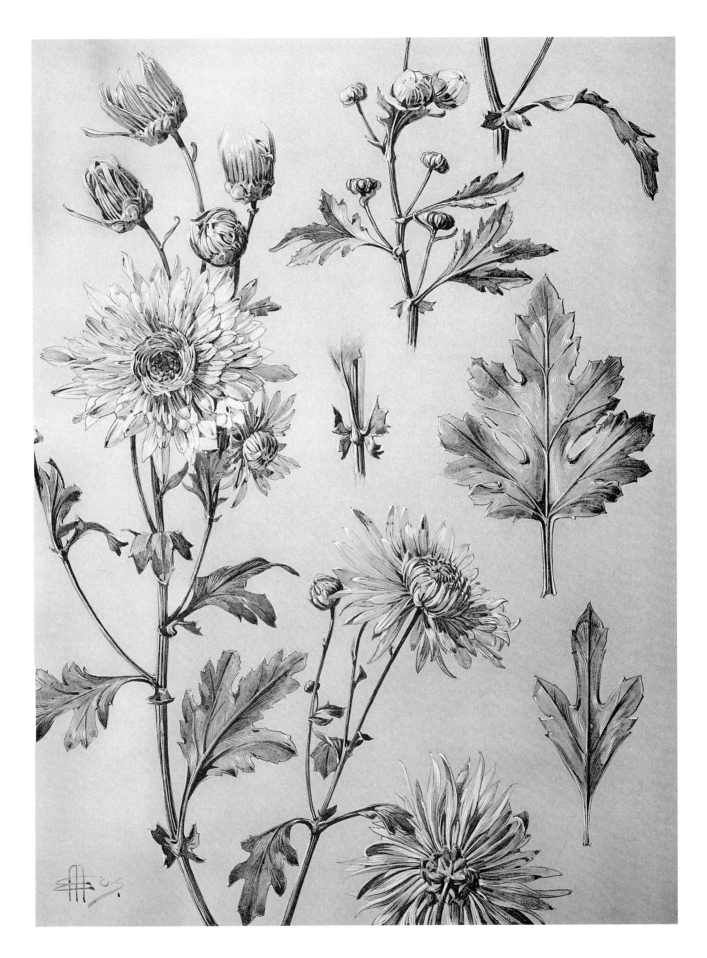

34 Chrysanthemum

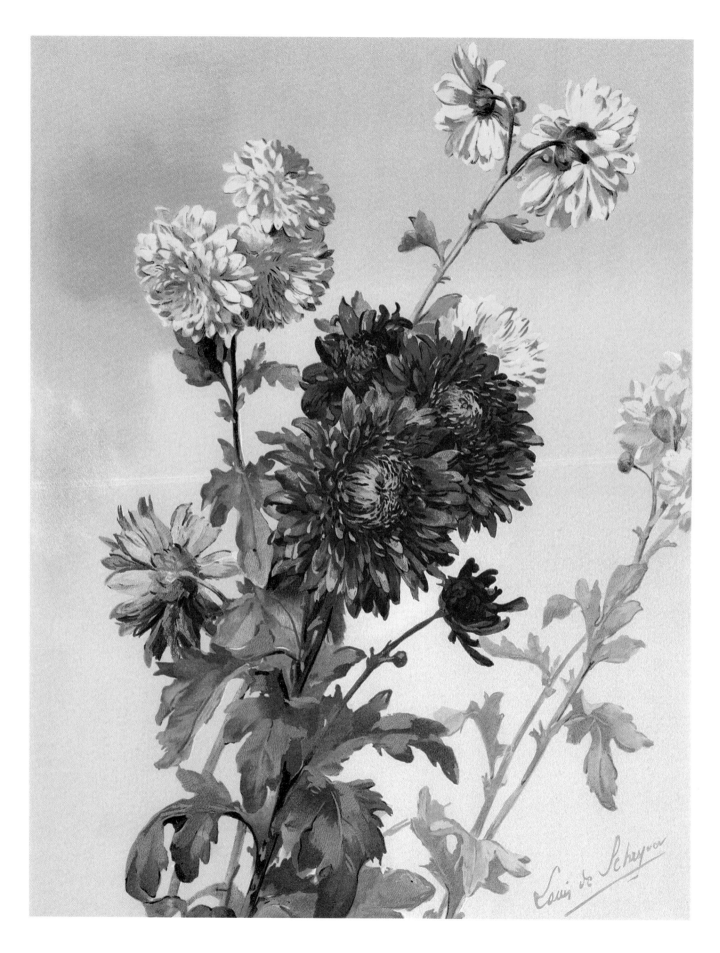

Louis de Scheyver

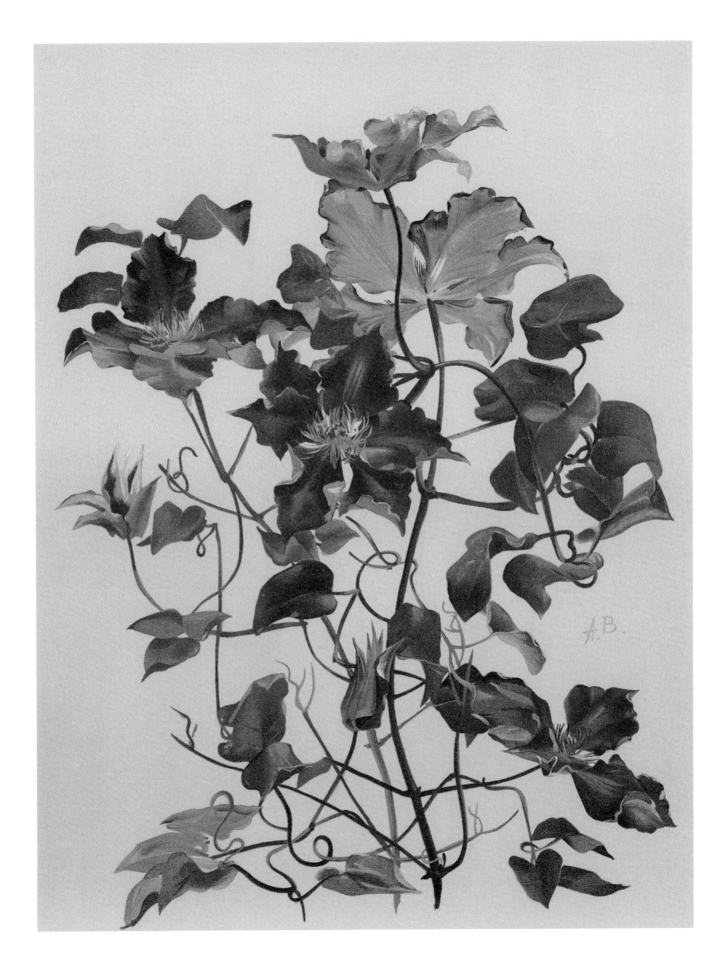

36 Clematis

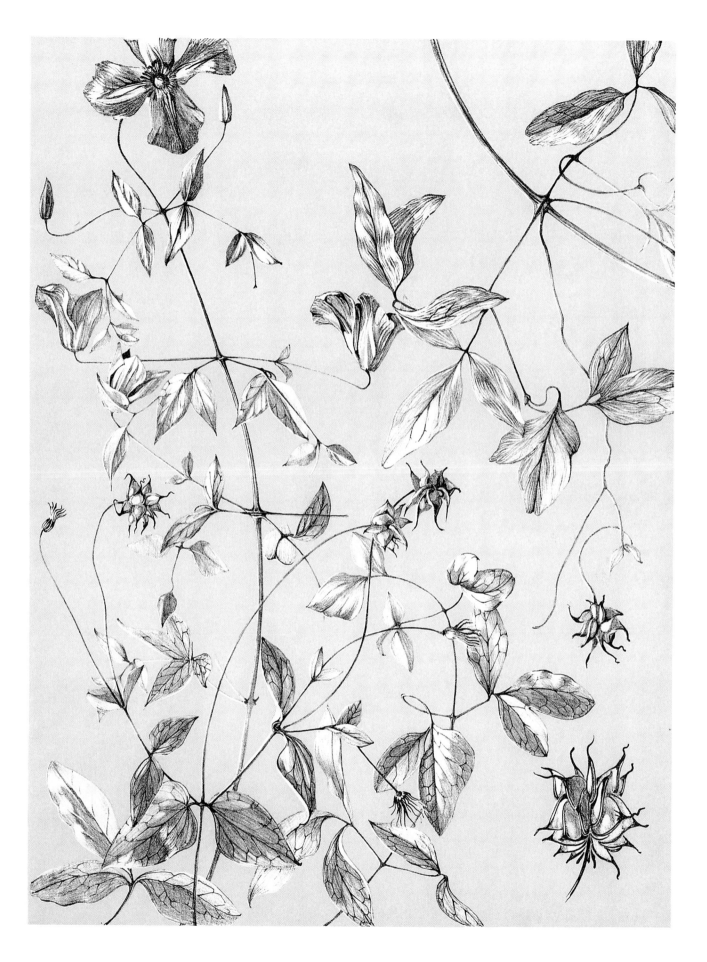

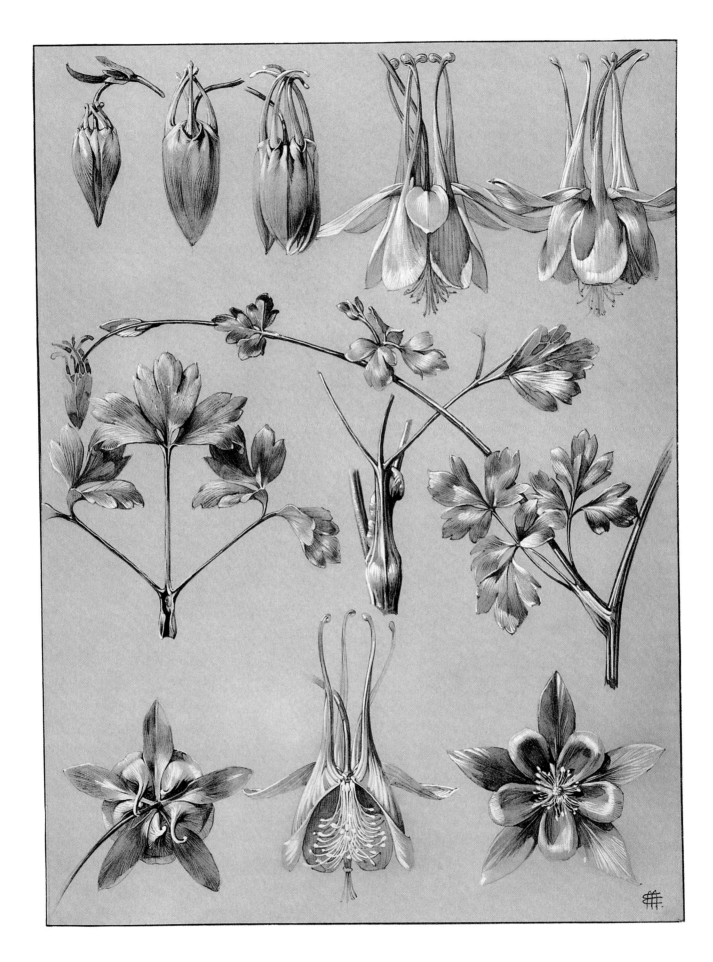

38 Columbine

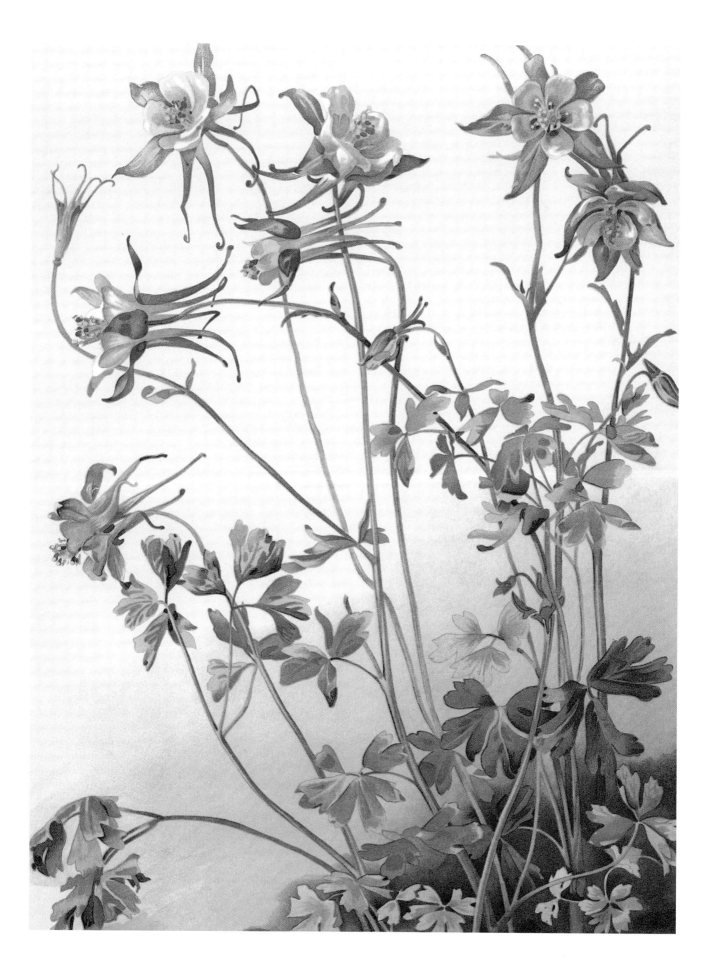

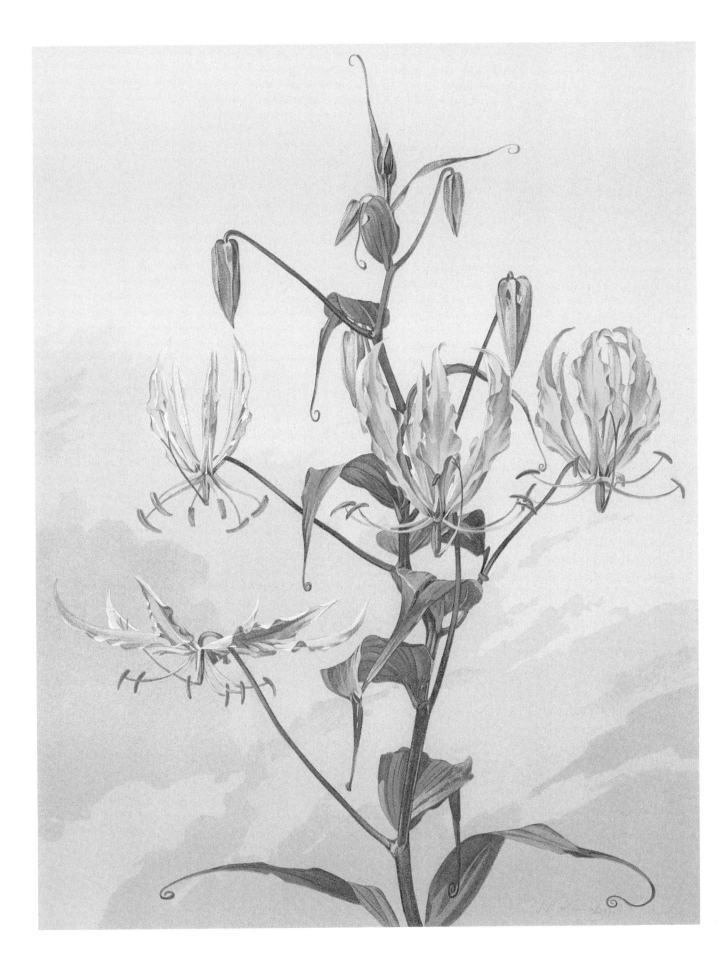

40 Congo lily

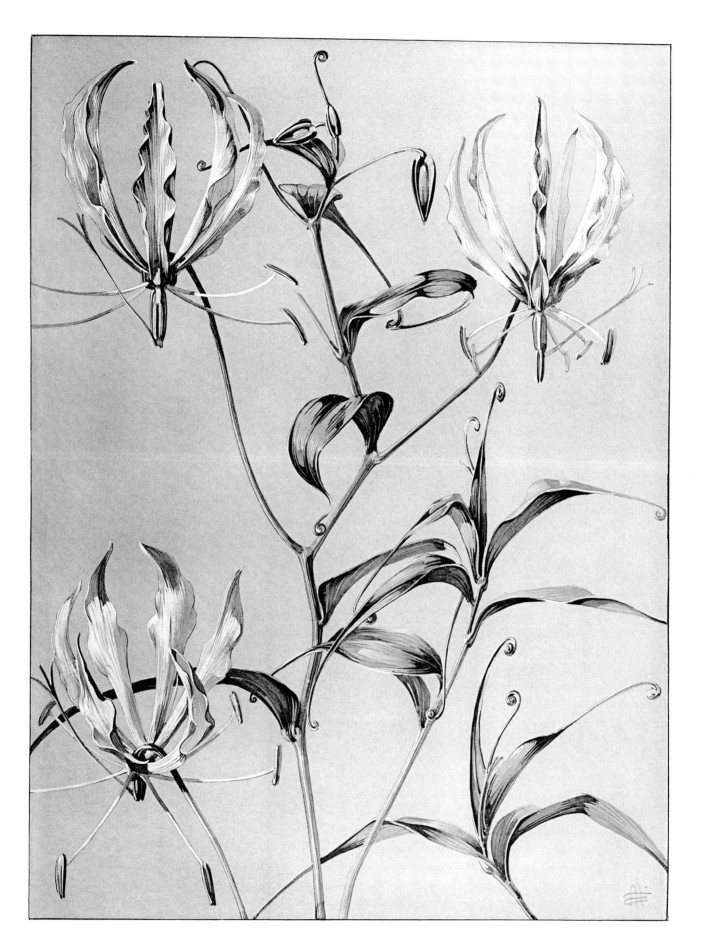

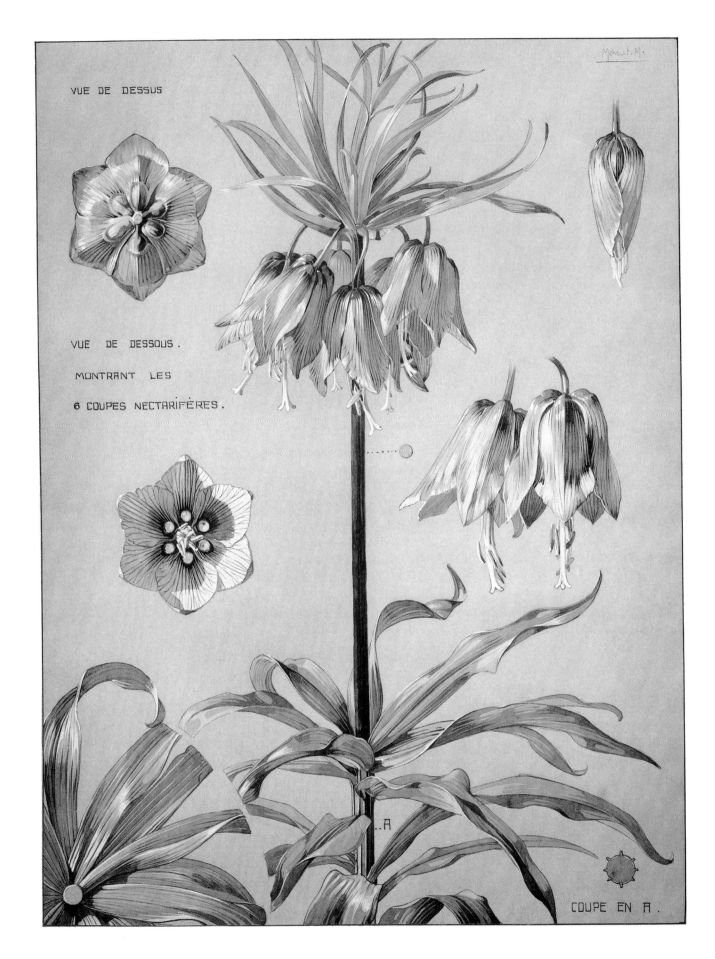

VUE DE DESSUS

VUE DE DESSOUS.

MONTRANT LES

6 COUPES NECTARIFÈRES.

COUPE EN A.

42 Crown imperial

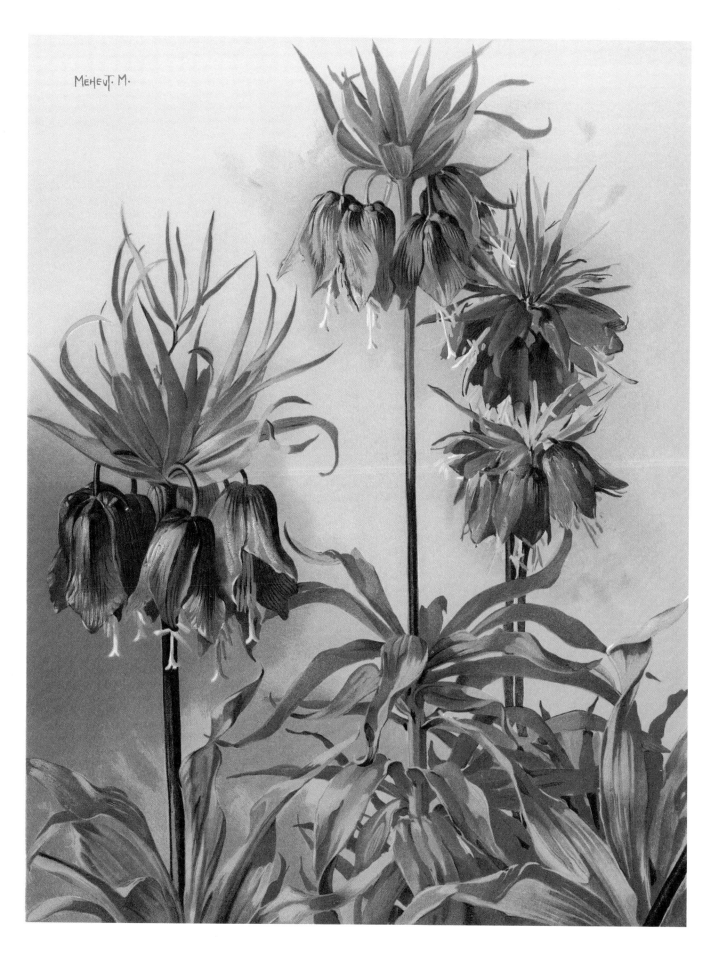

MÉHEUT. M.

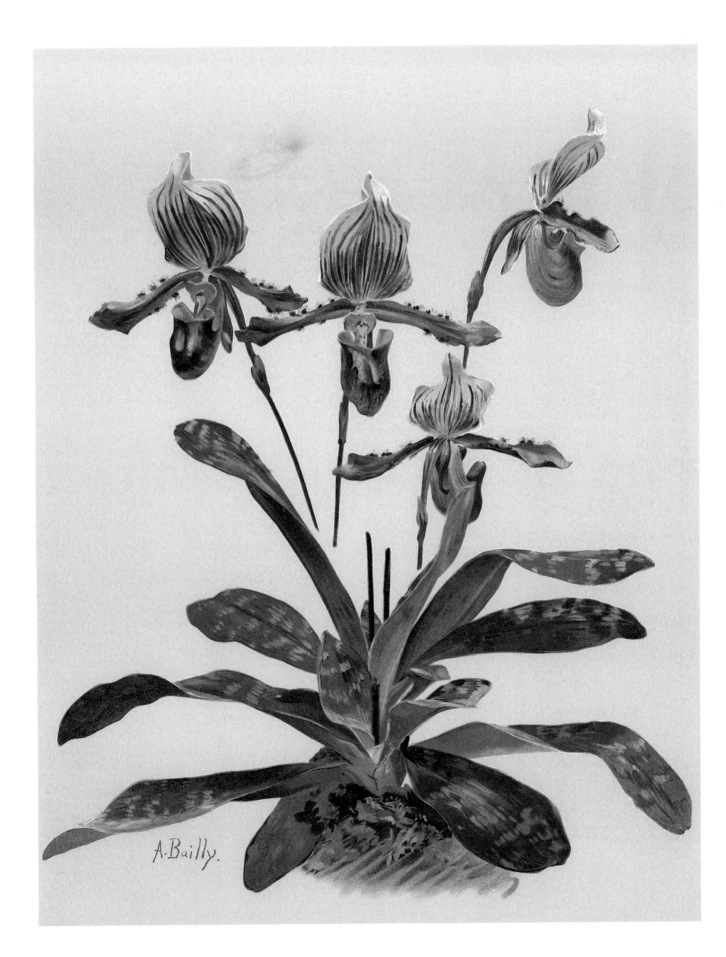

44 Cypripedium orchid

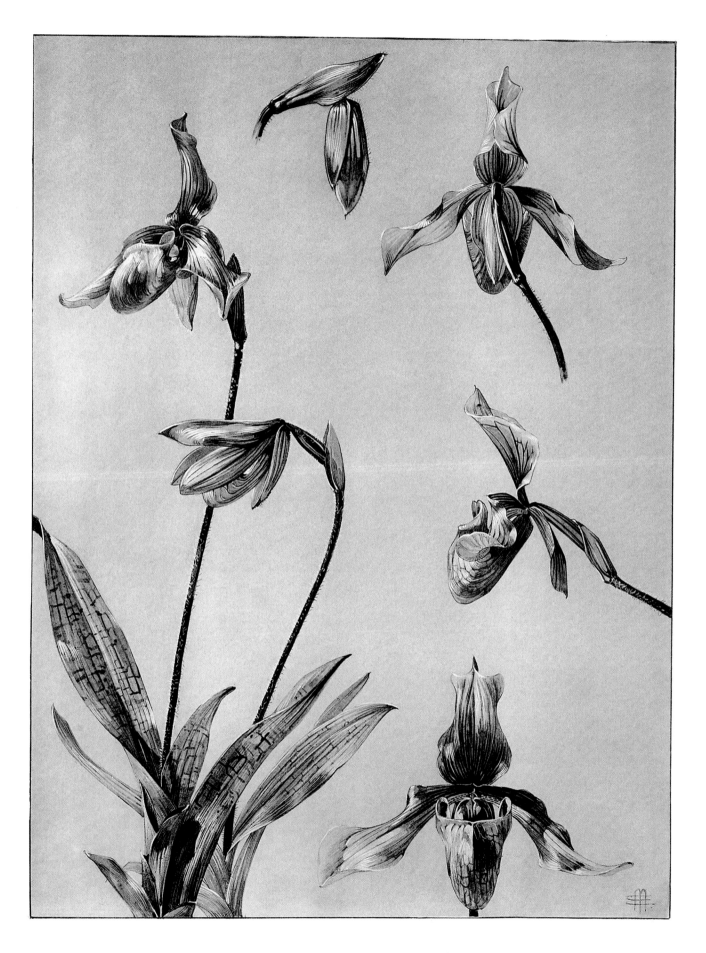

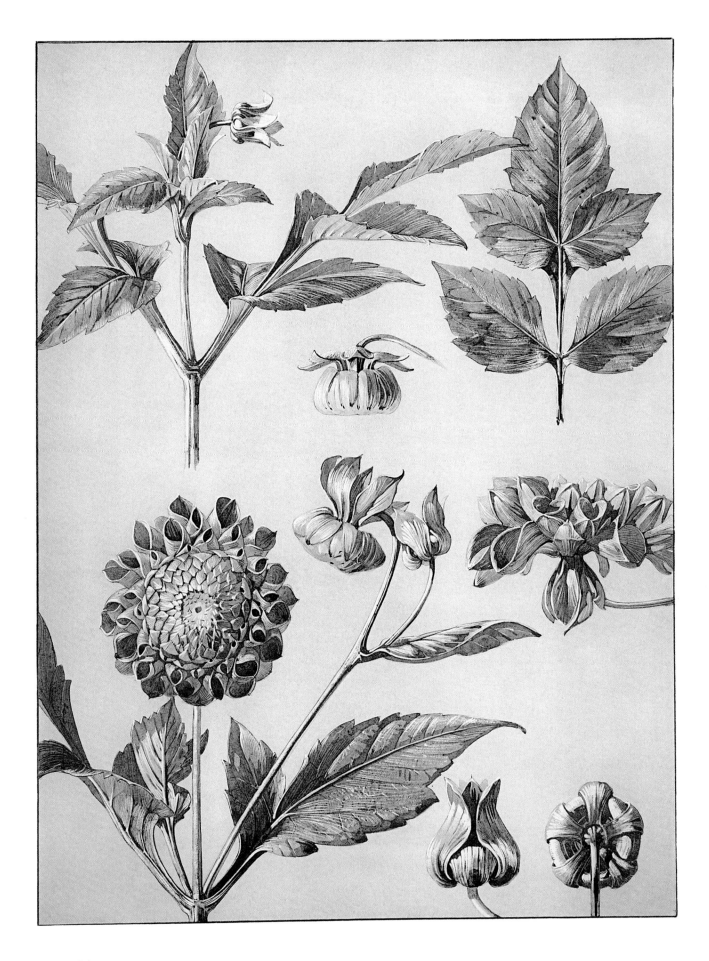

46 Dahlia

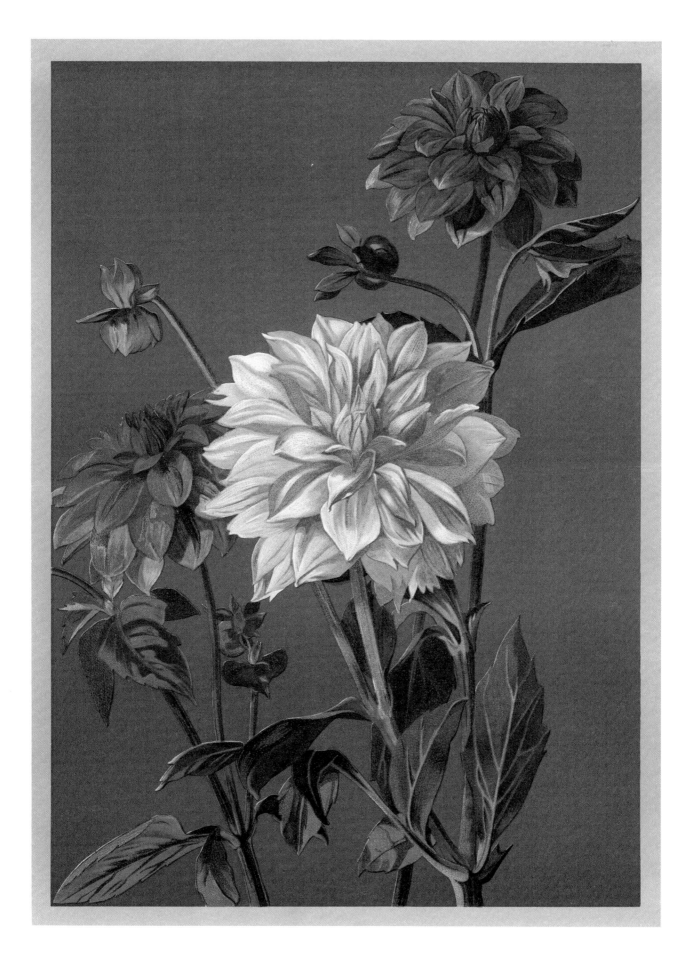

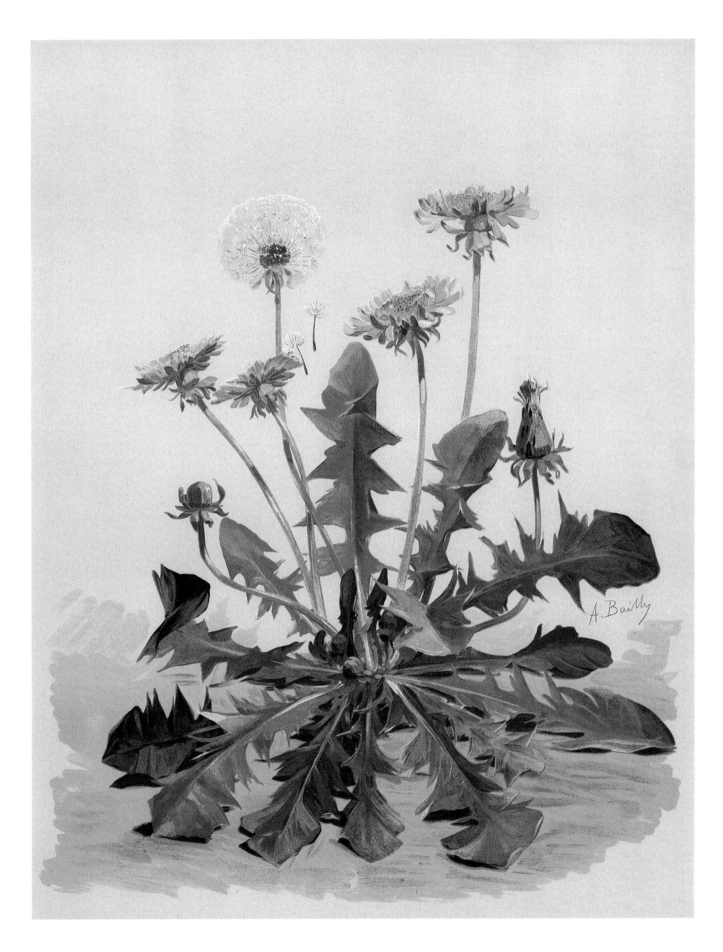

48 Dandelion

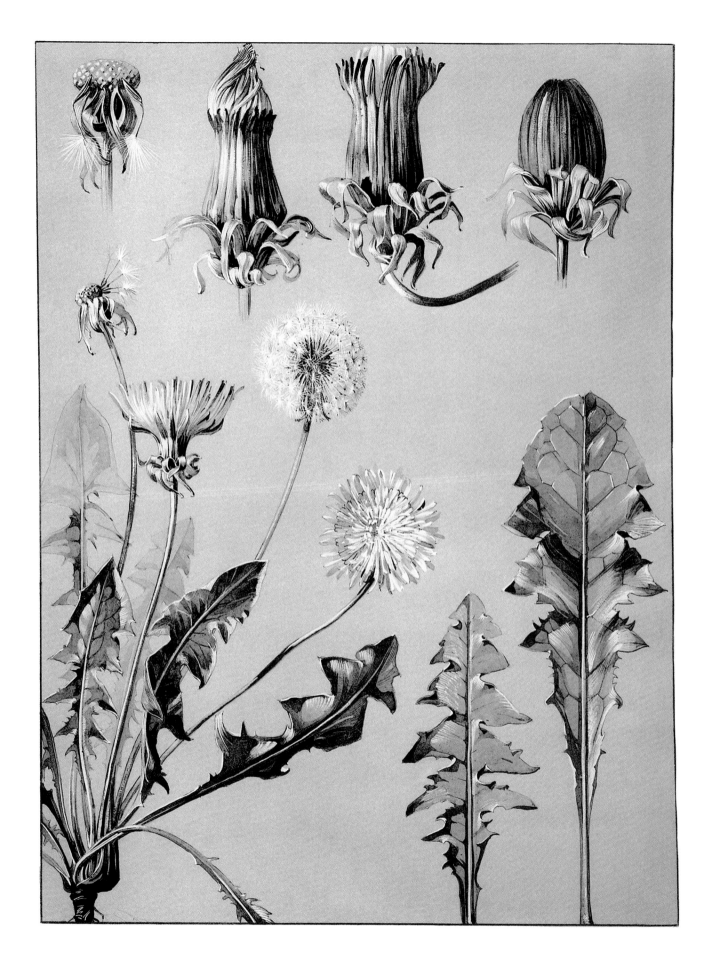

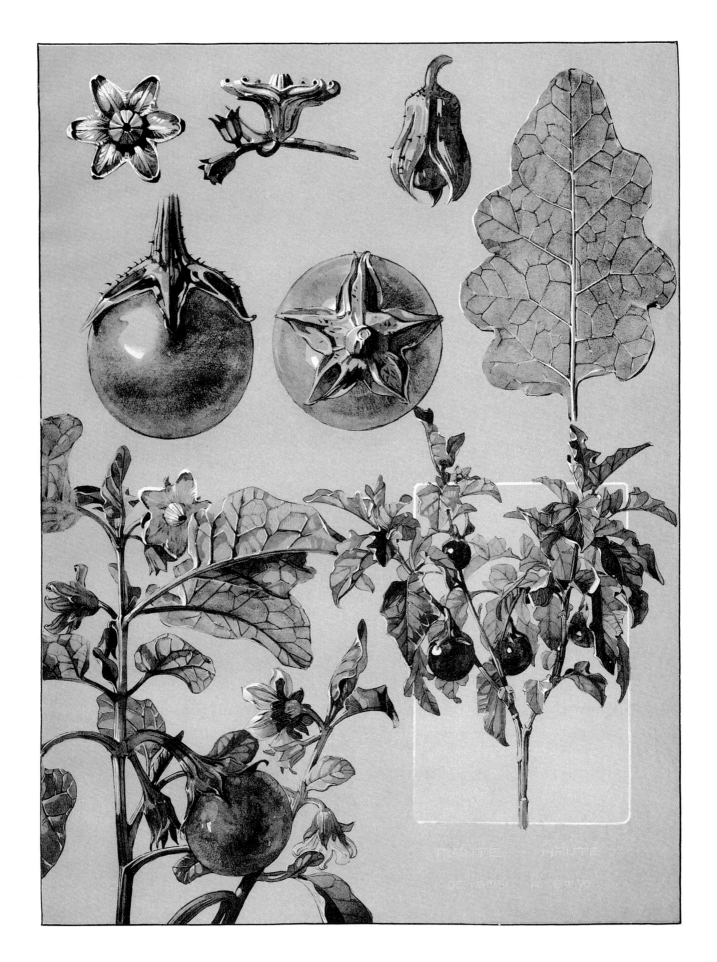

50 Eggplant

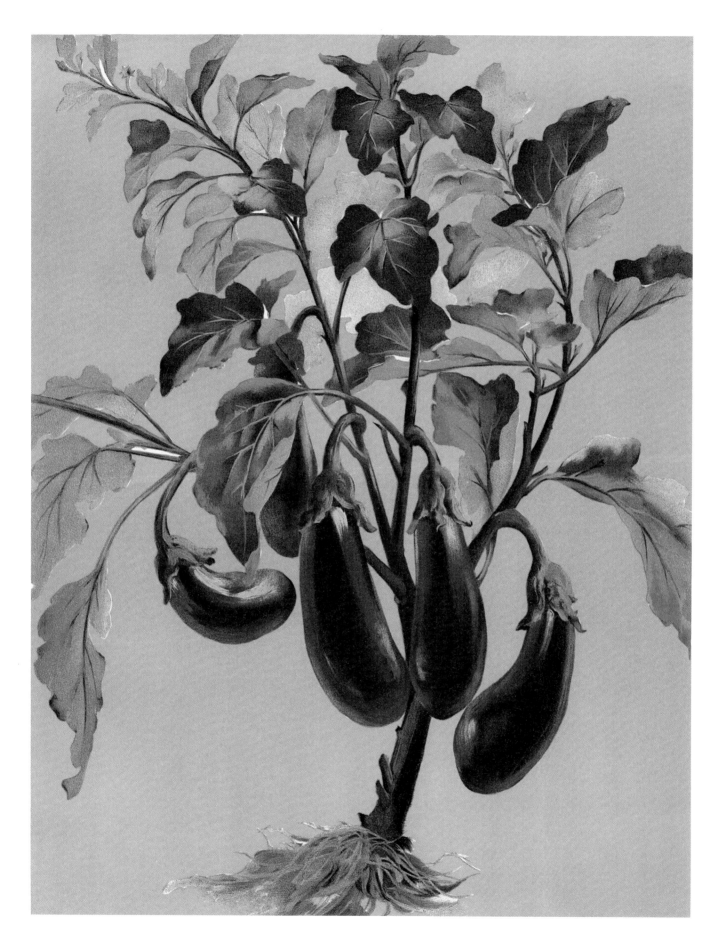

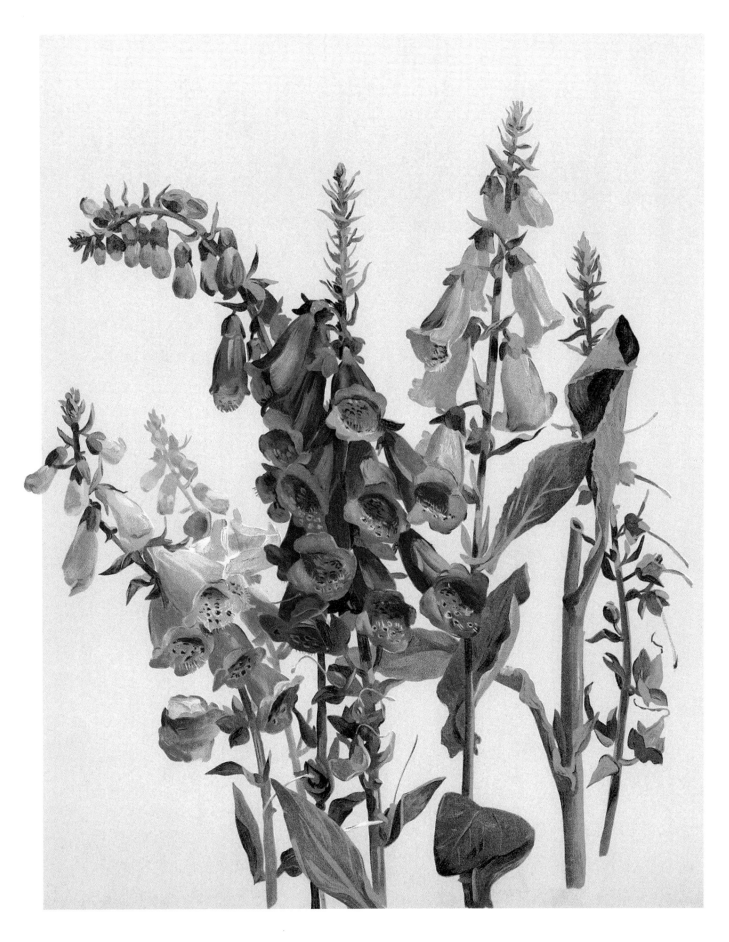

52 Foxglove

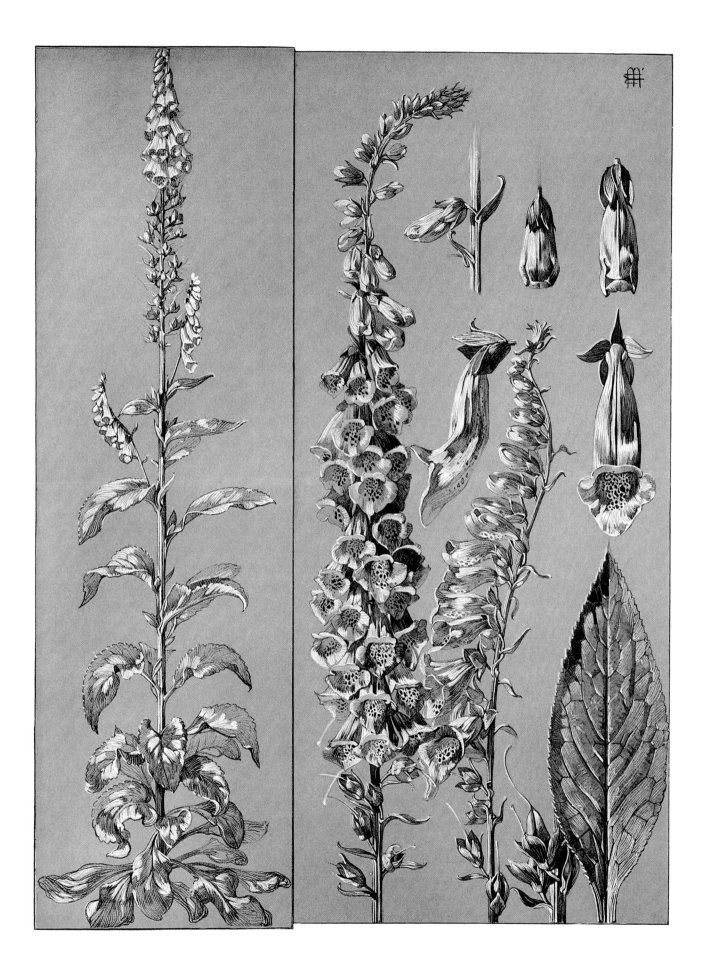

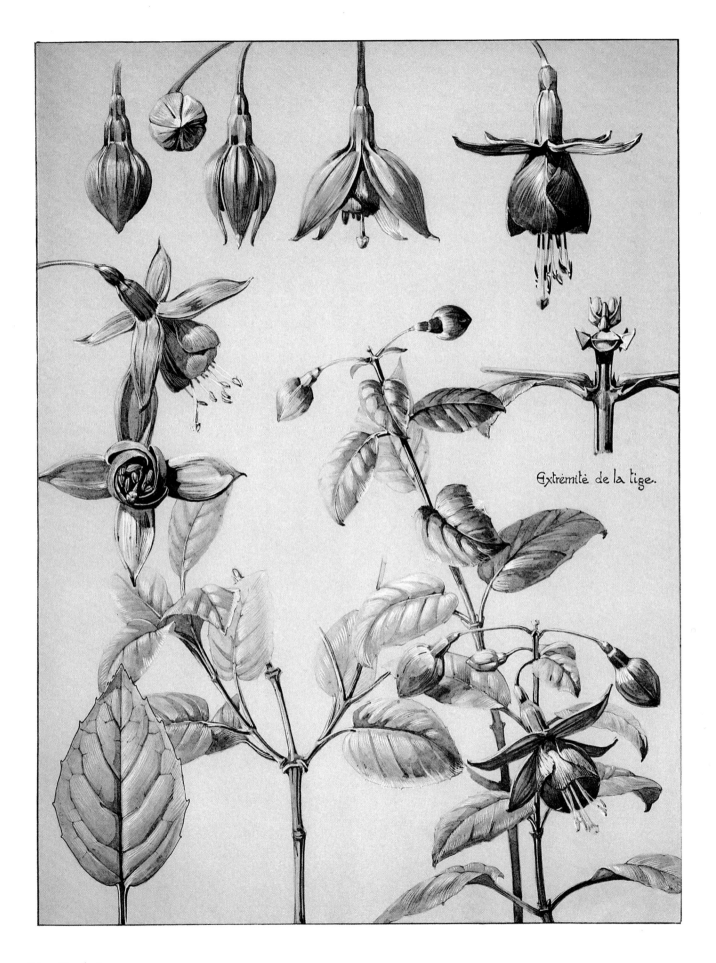

Extrémité de la tige.

54 Fuchsia

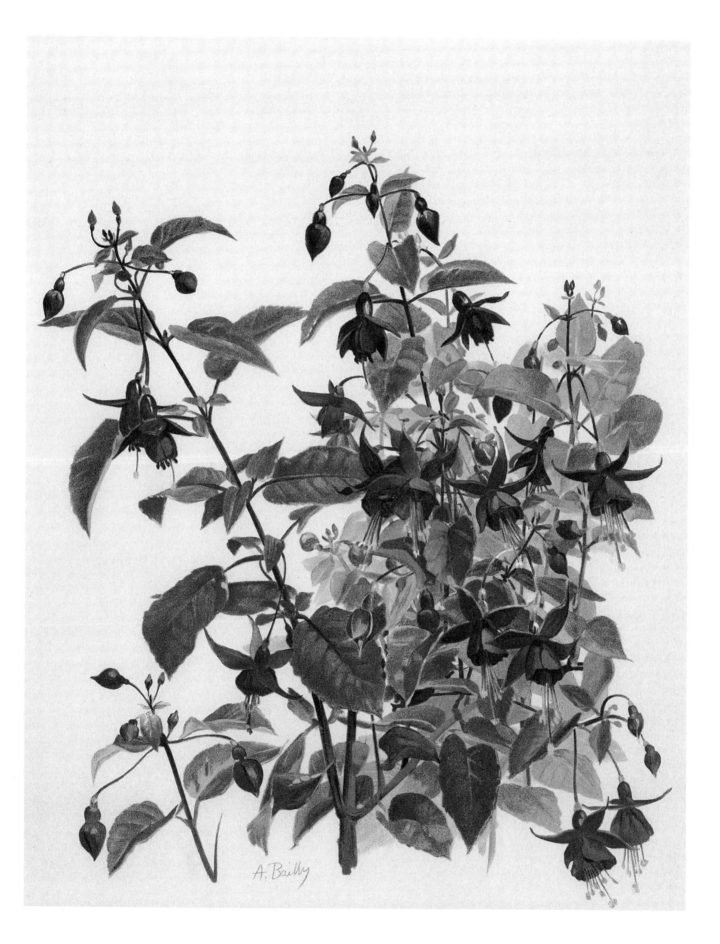

A. Bailly

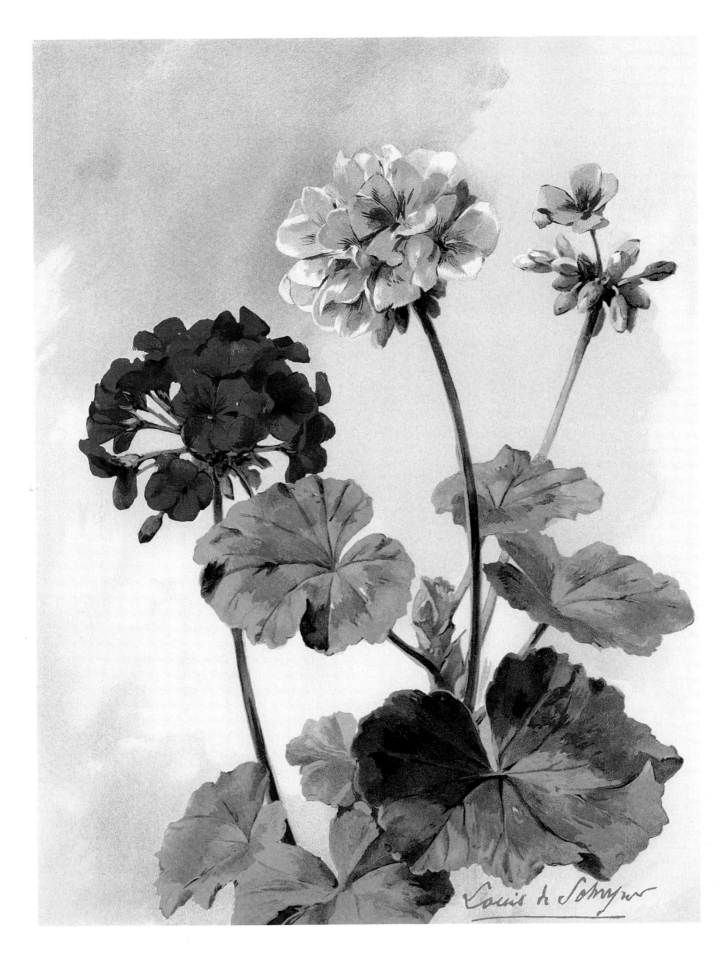

56 Geranium

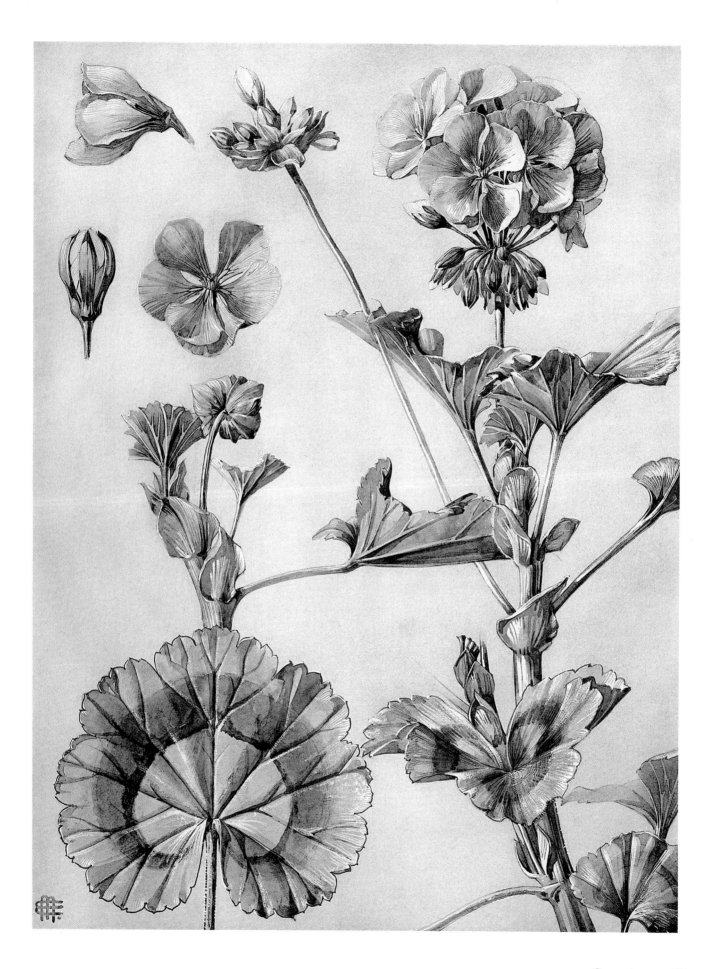

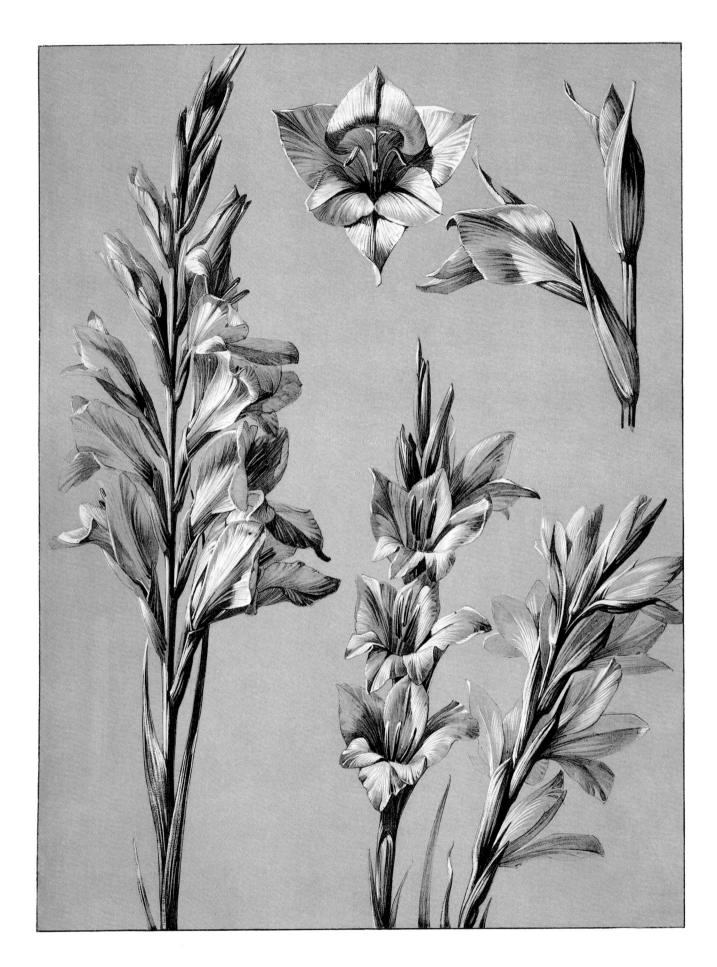

58 Gladiolus

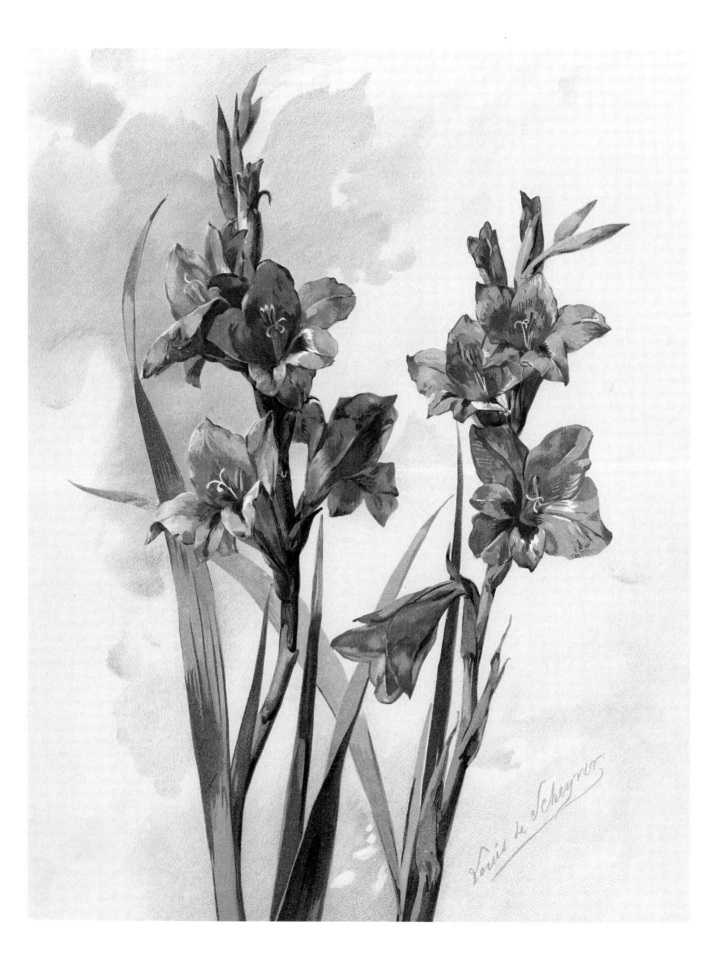

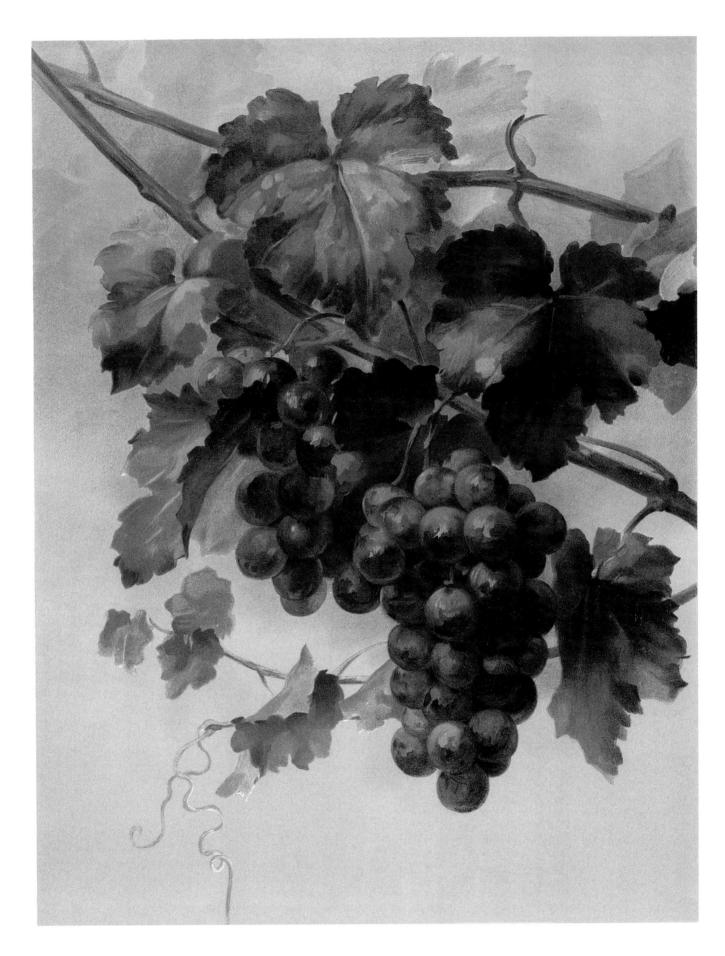

60 Grape

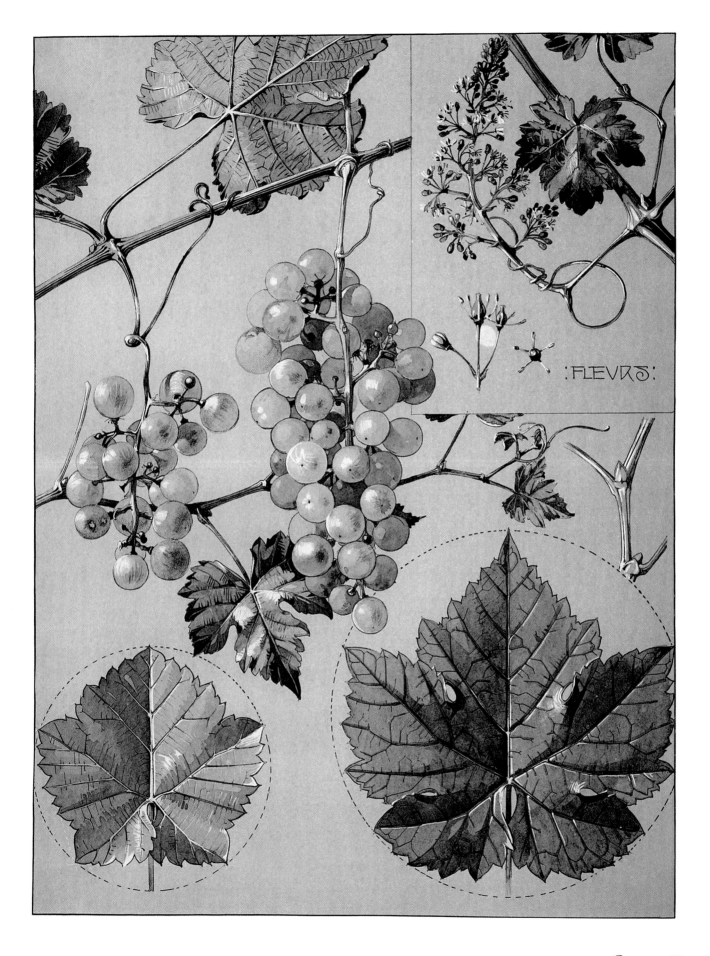

FLEVRS

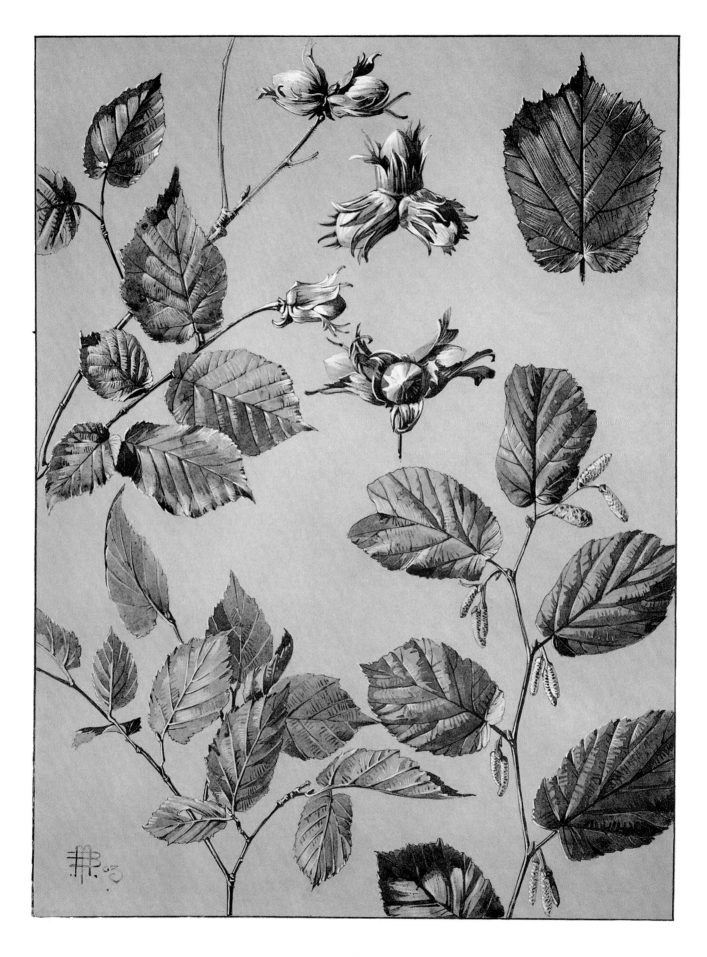

62 Hazel

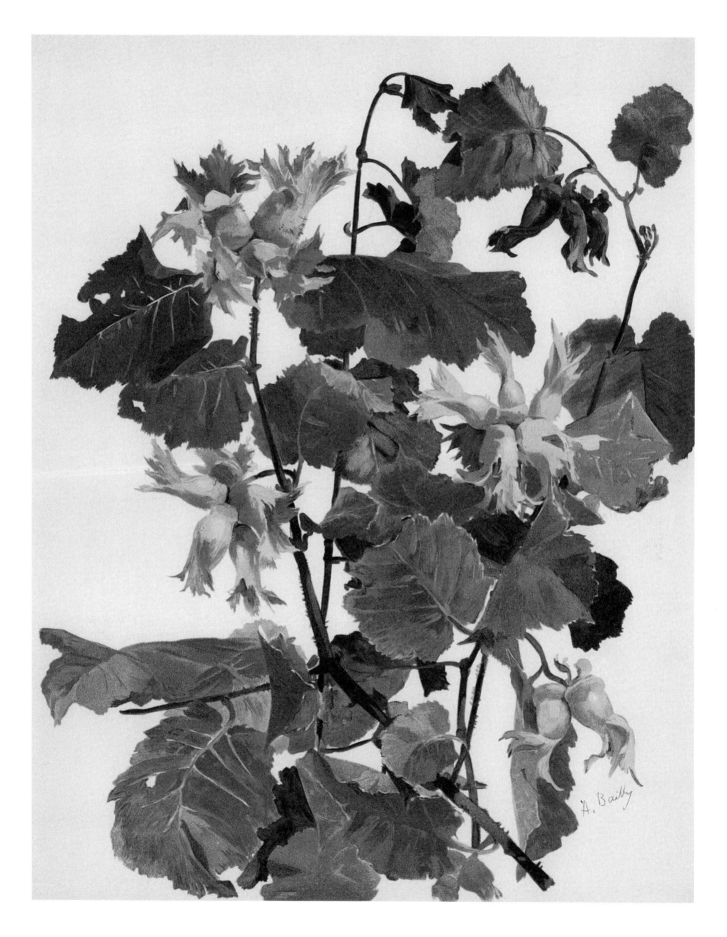

A. Bailly

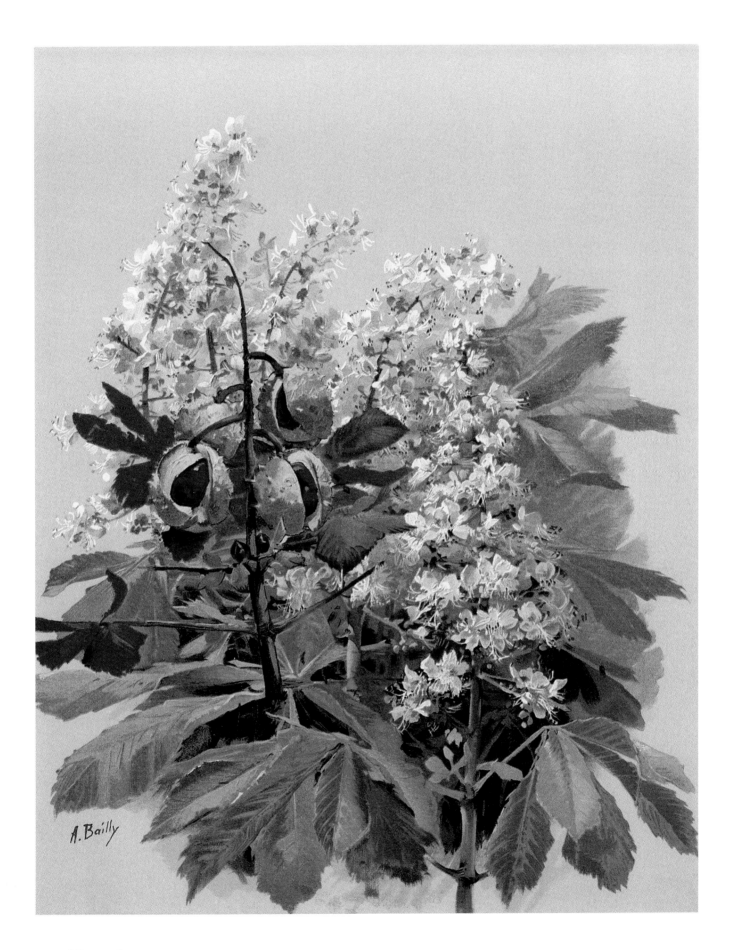

64 Horse chestnut

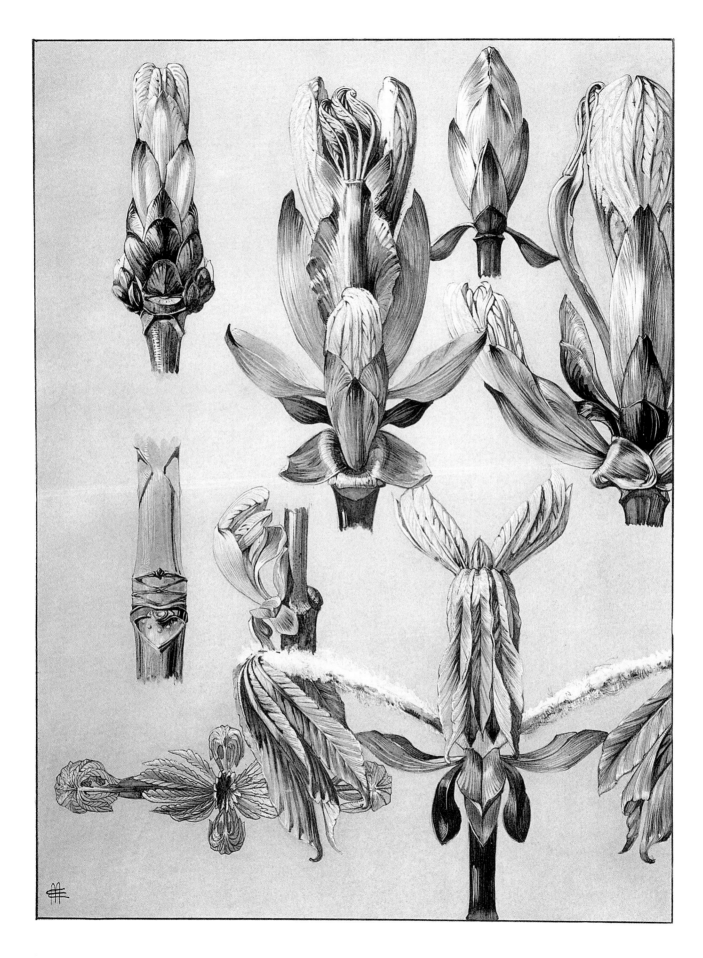

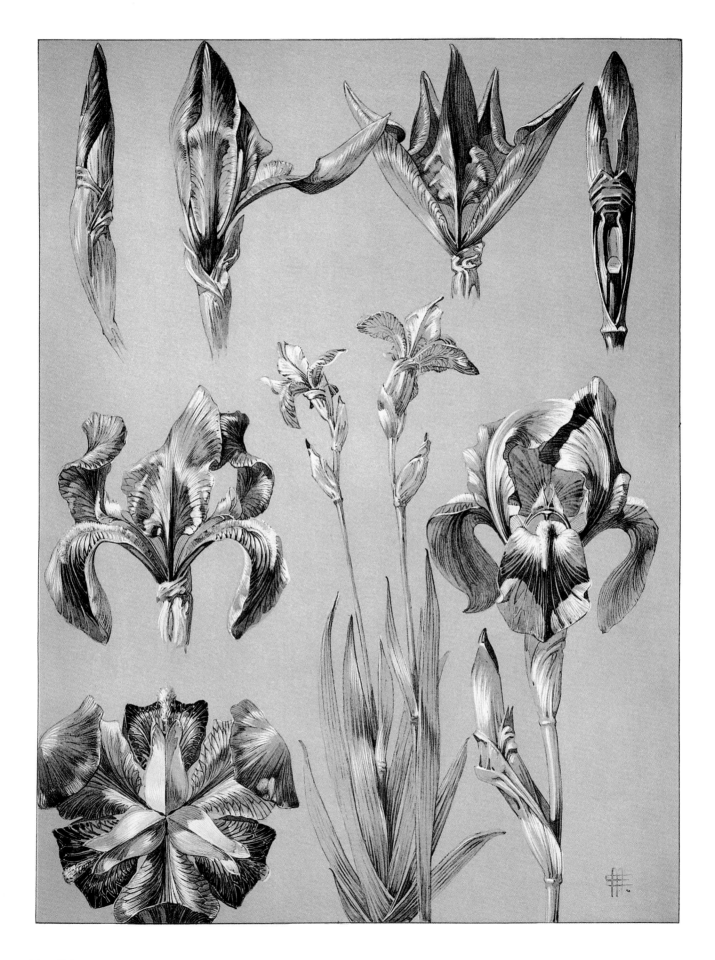

66 Iris

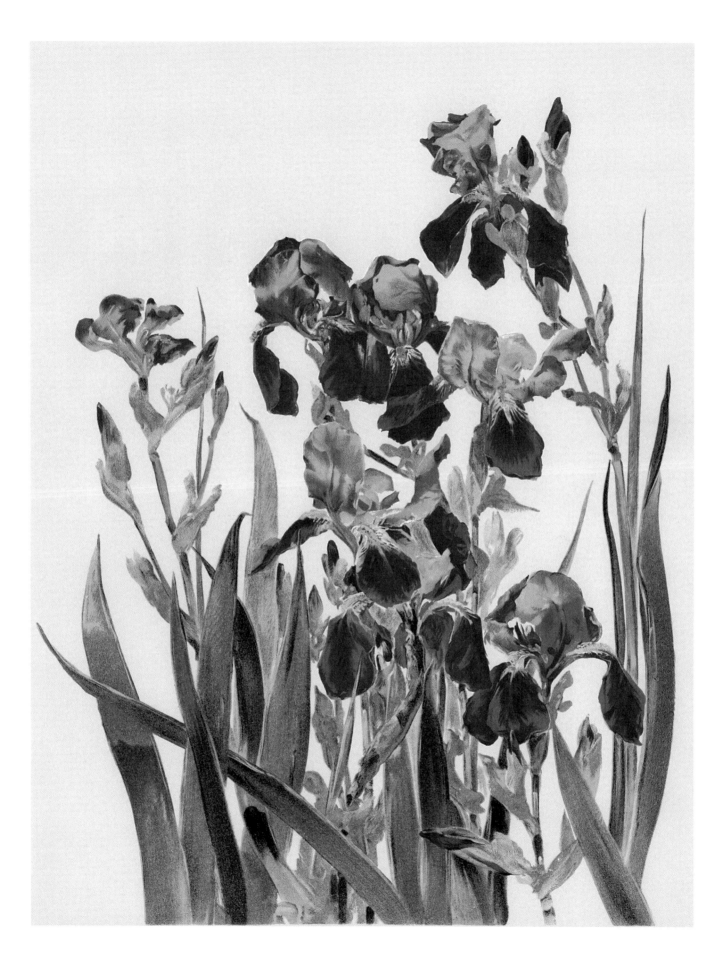

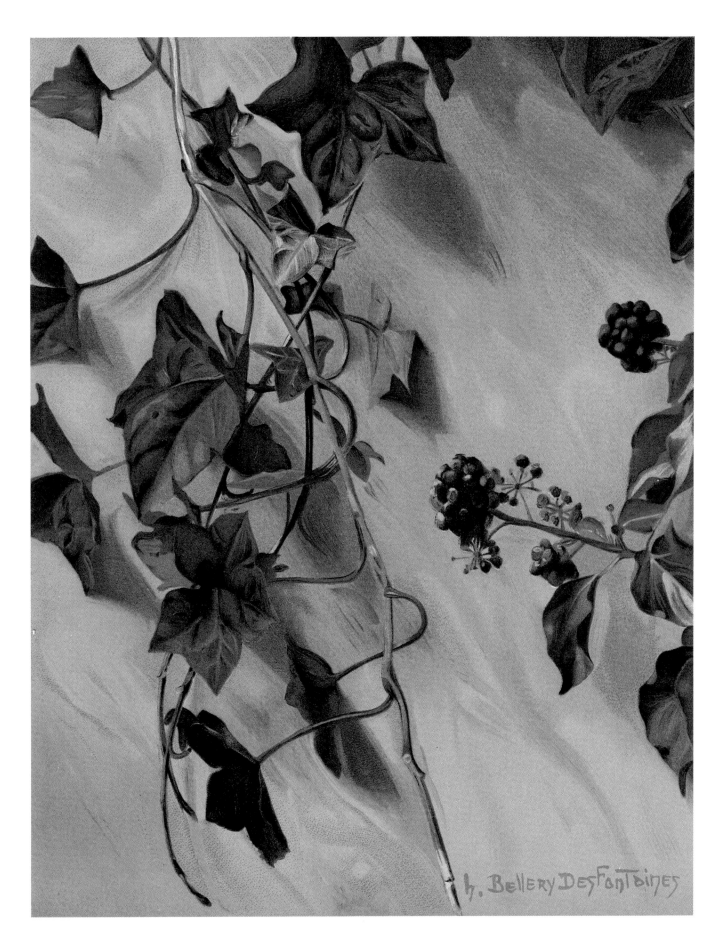

68 Ivy

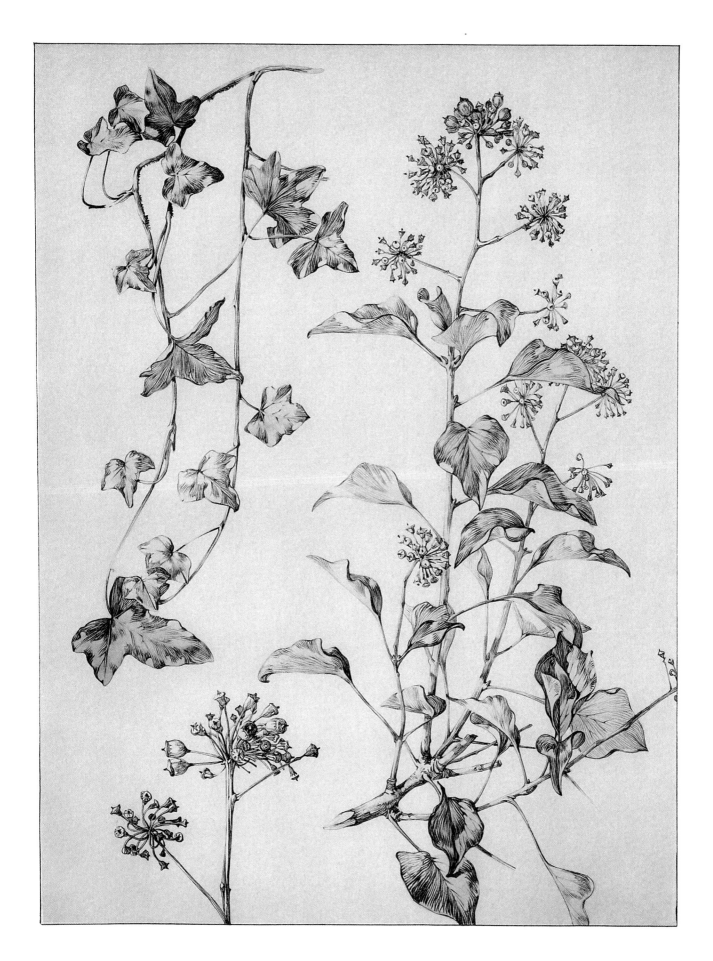

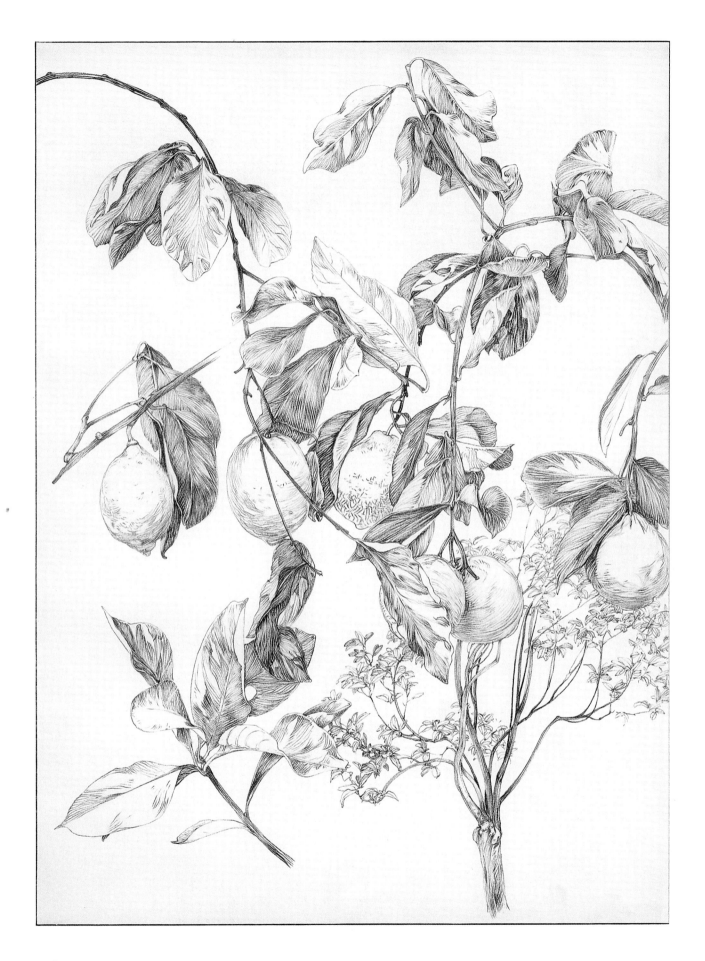

70 Lemon

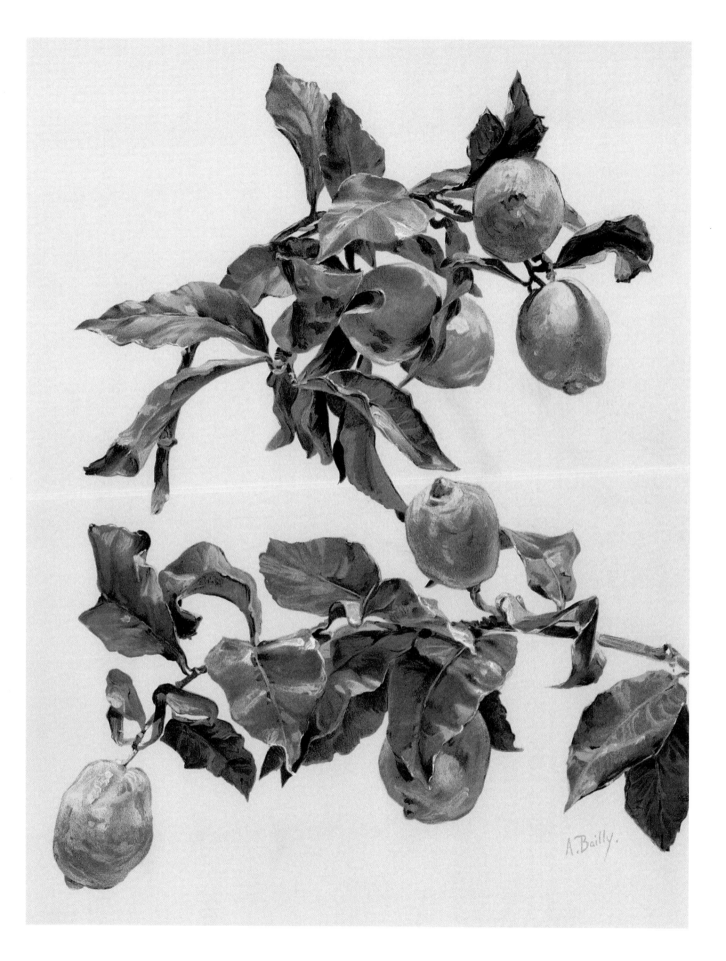

A. Bailly.

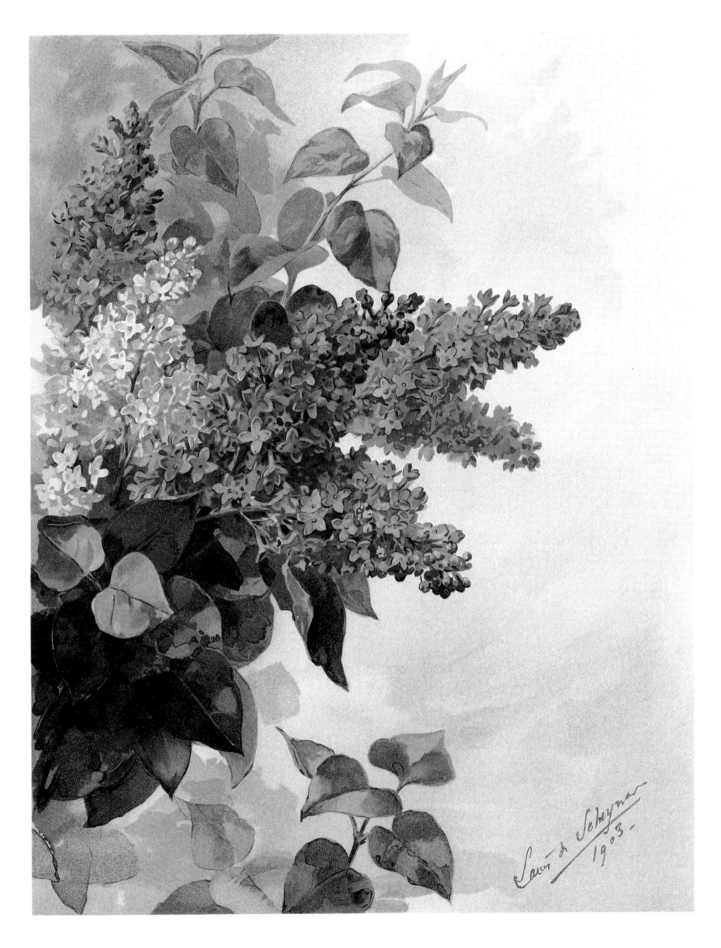

72 Lilac

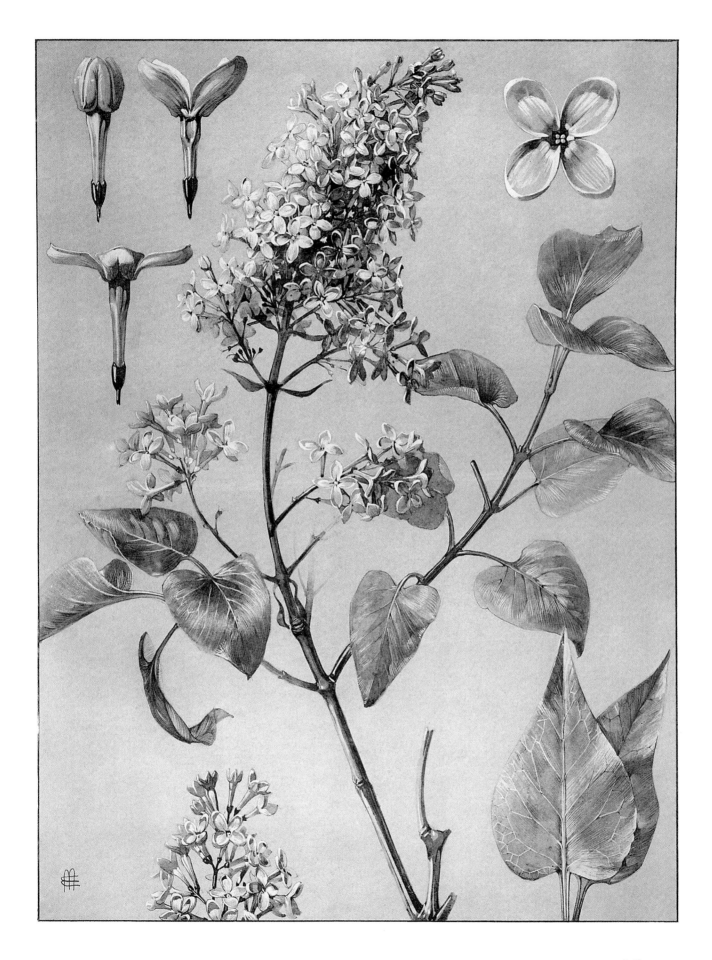

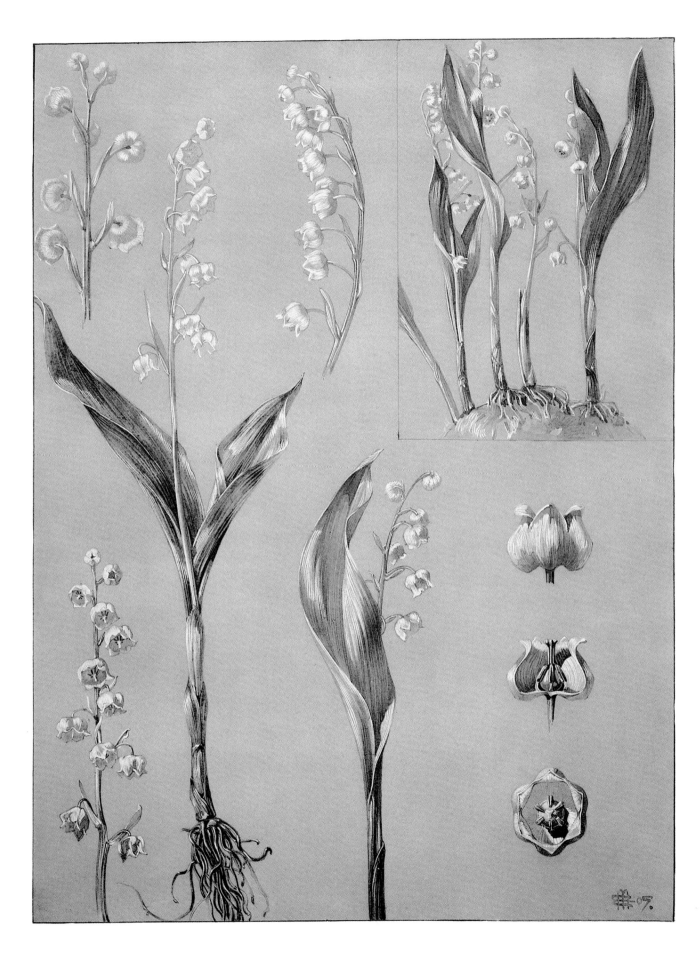

74 Lily of the valley

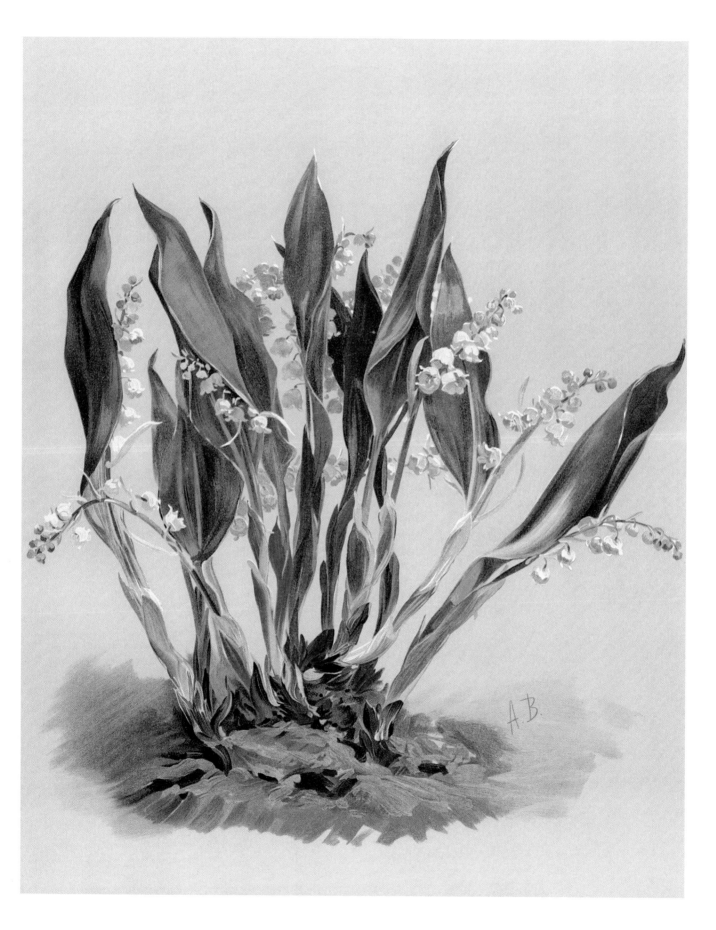

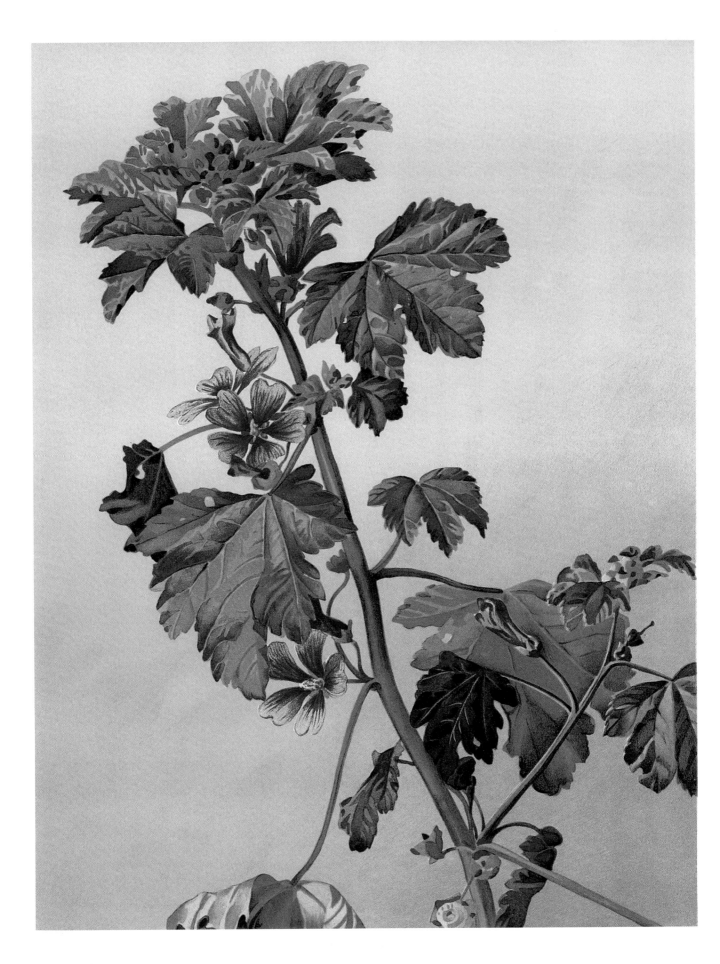

76 Malva

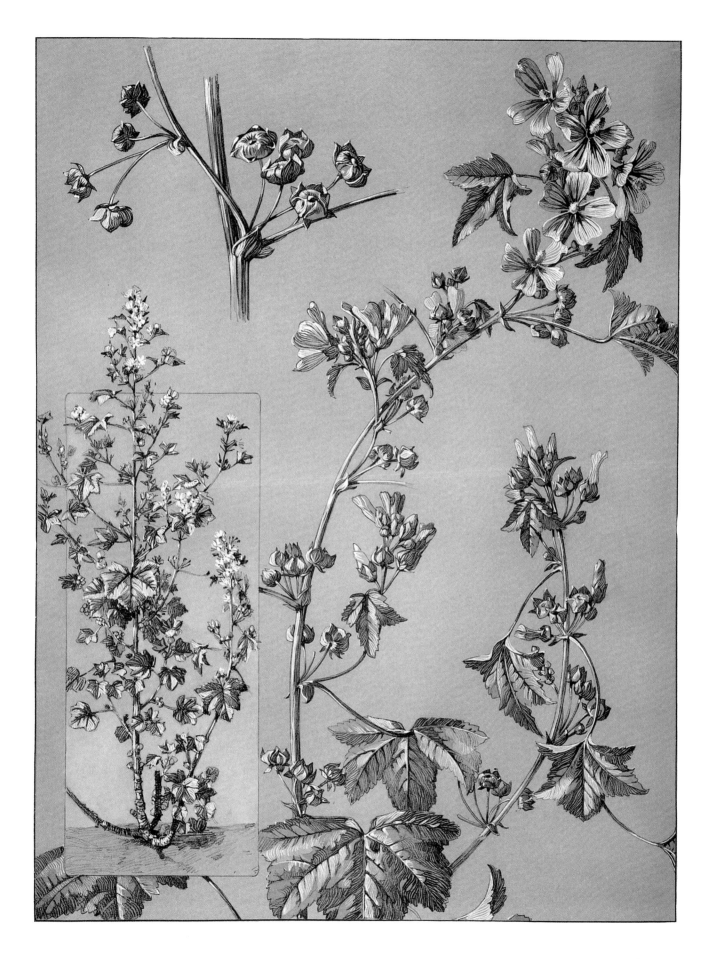

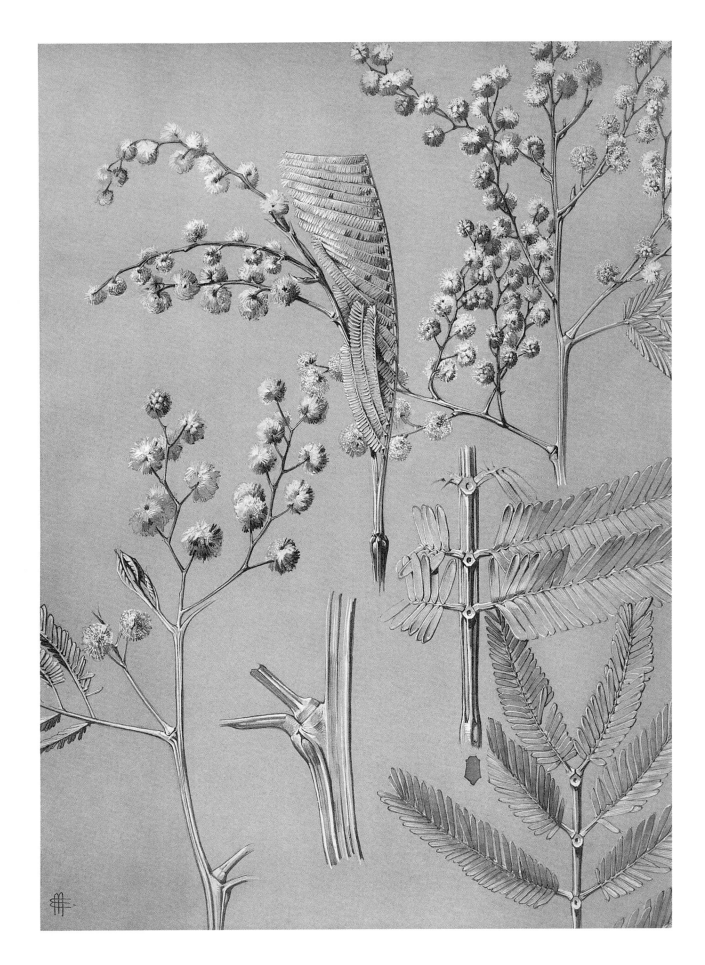

78　Mimosa

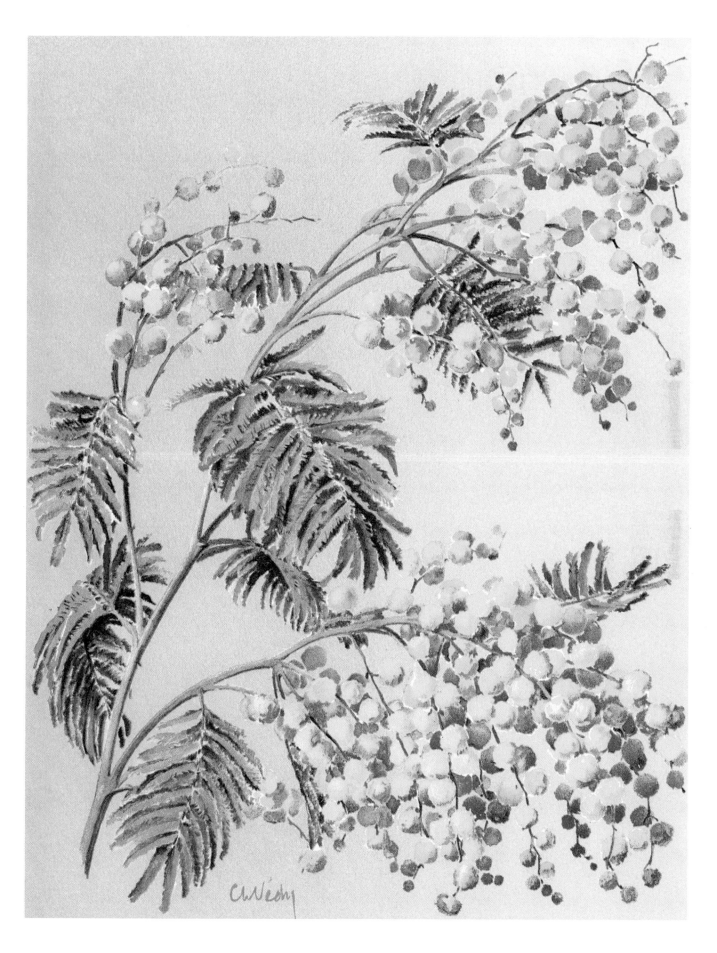

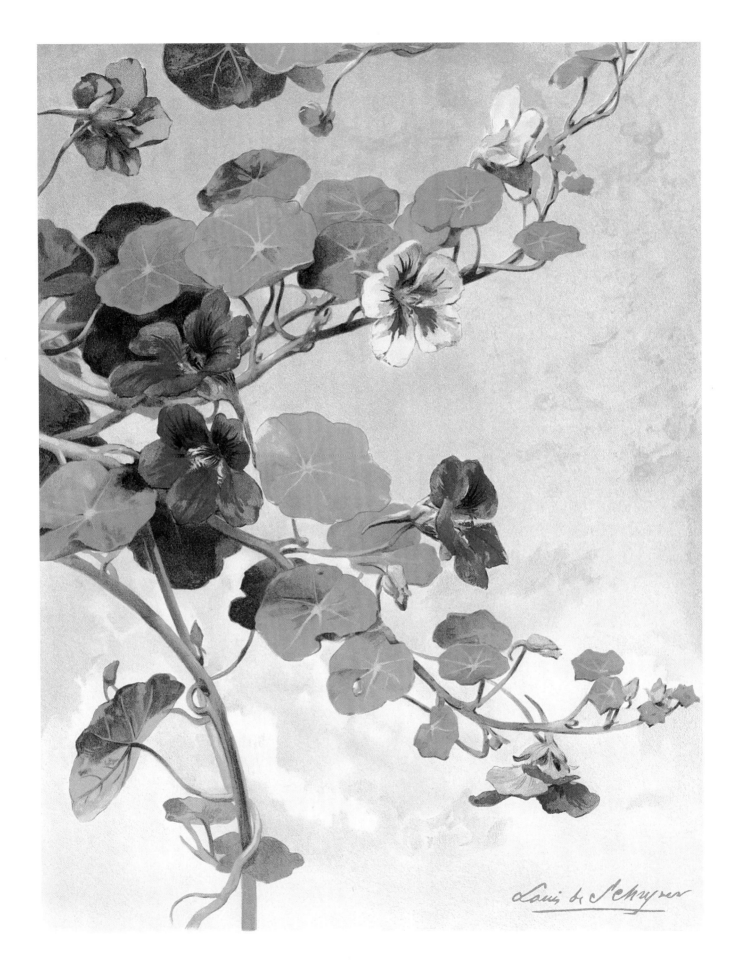

80 Nasturtium

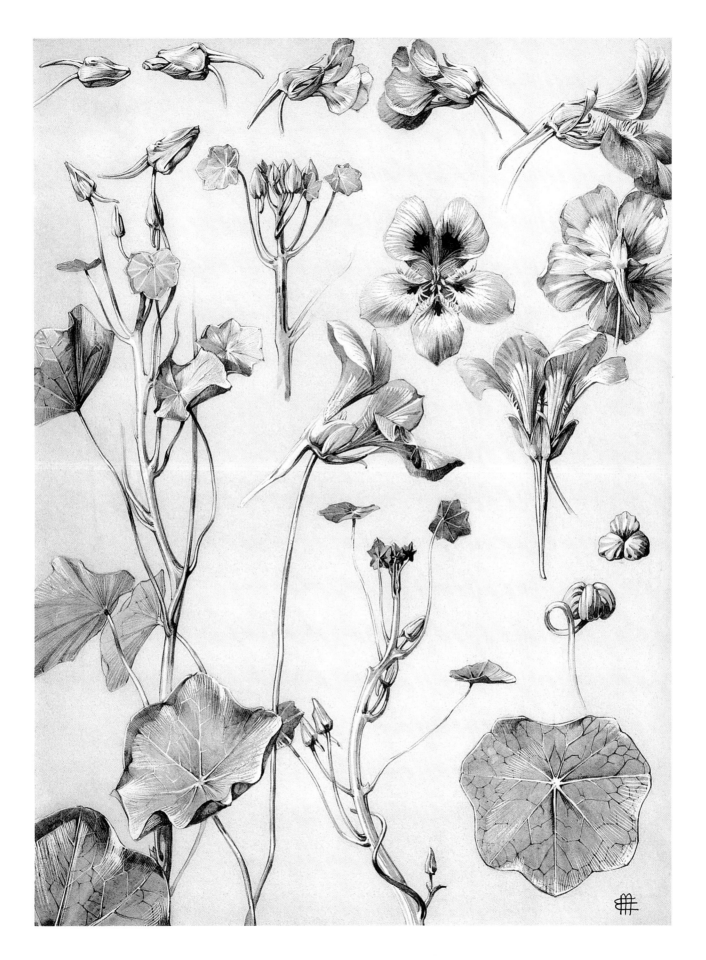

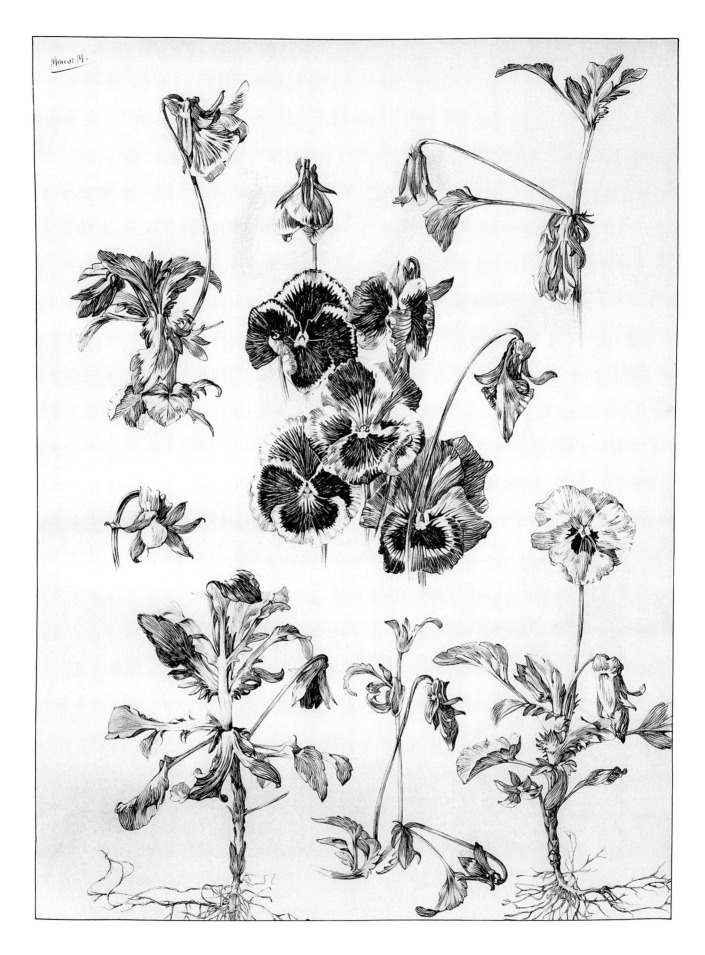

Meheut M.

82 Pansy

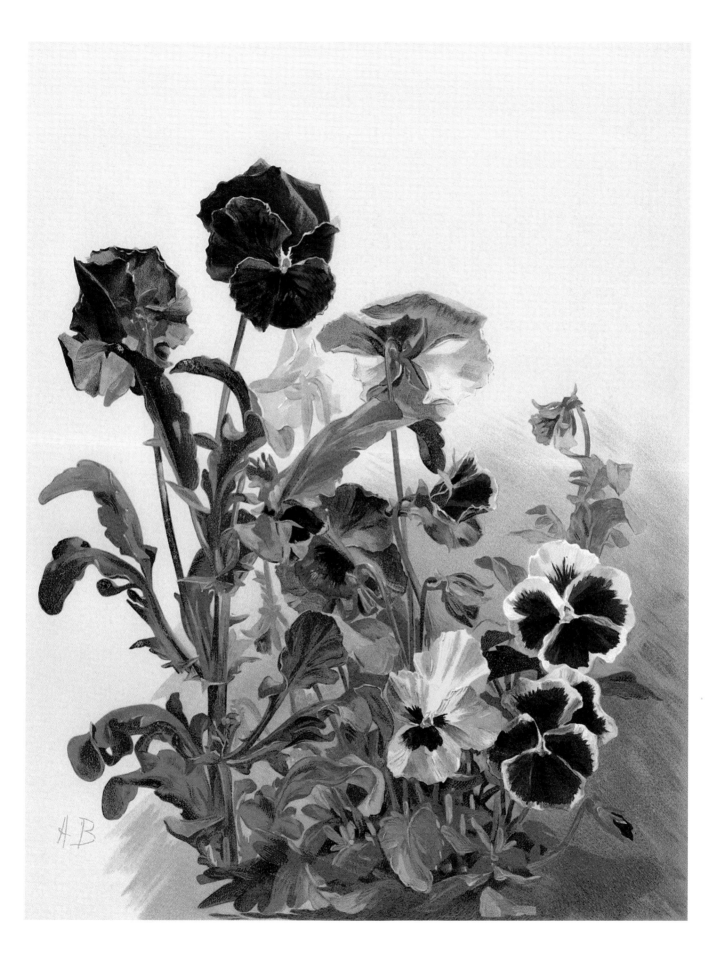

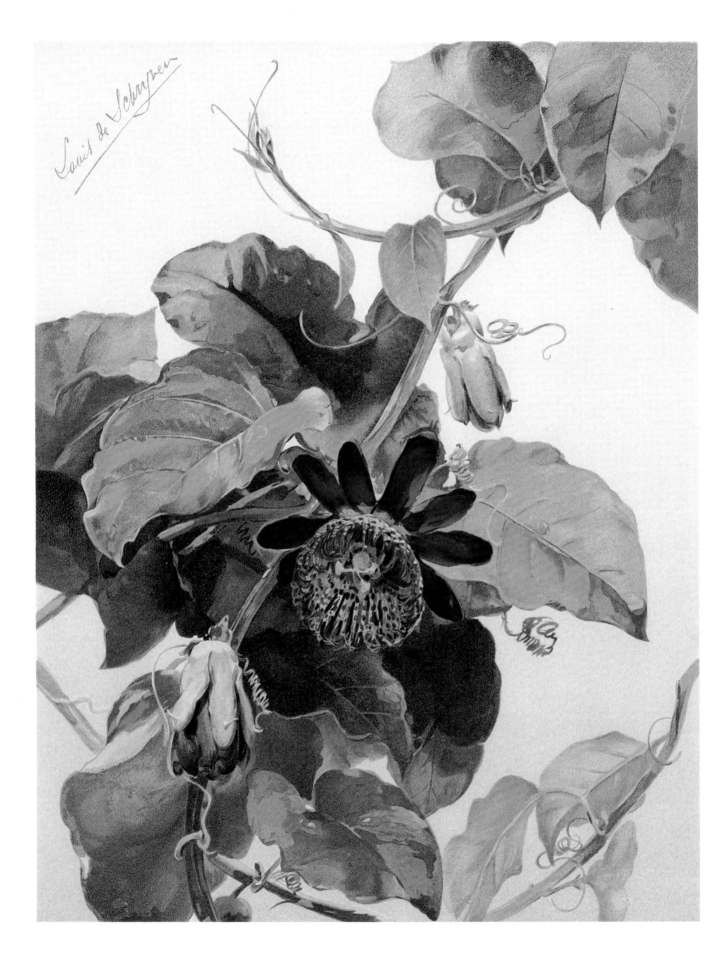

84 Passion flower

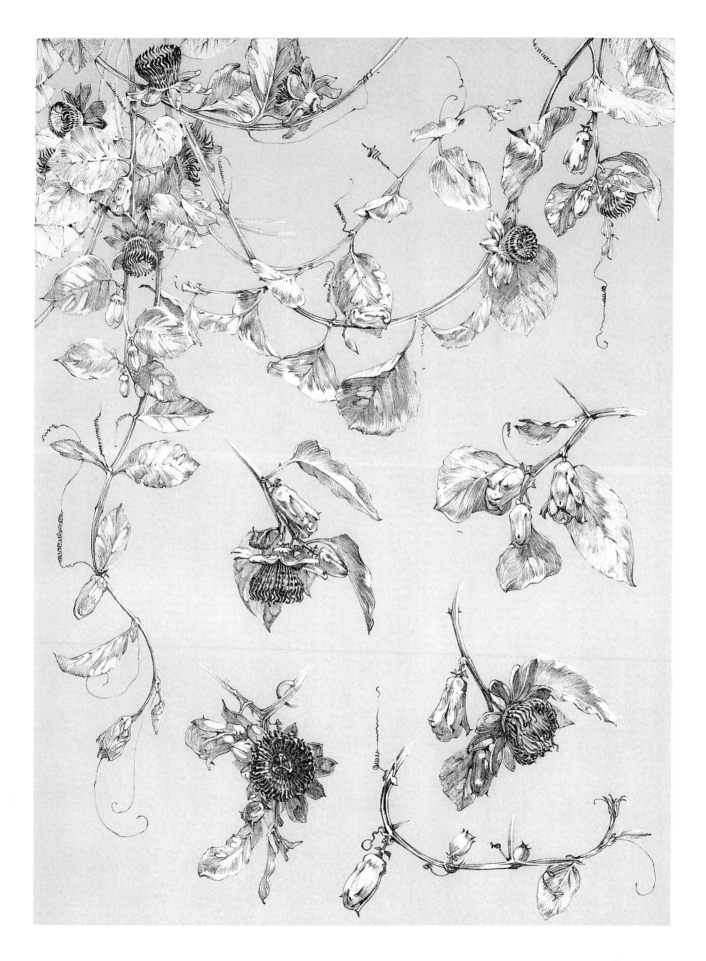

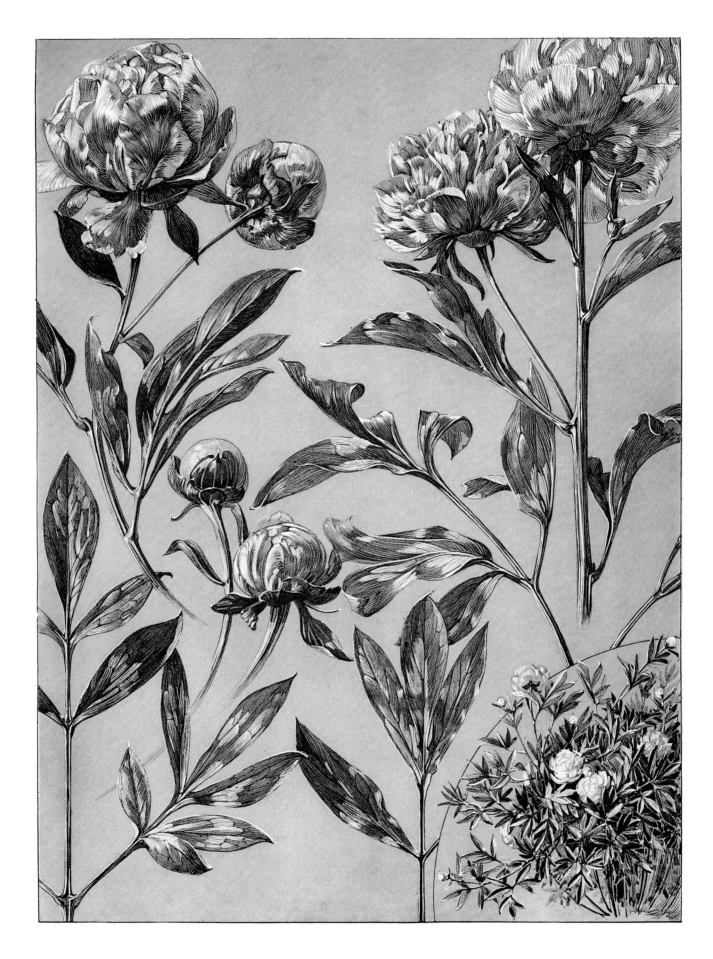

86 Peony

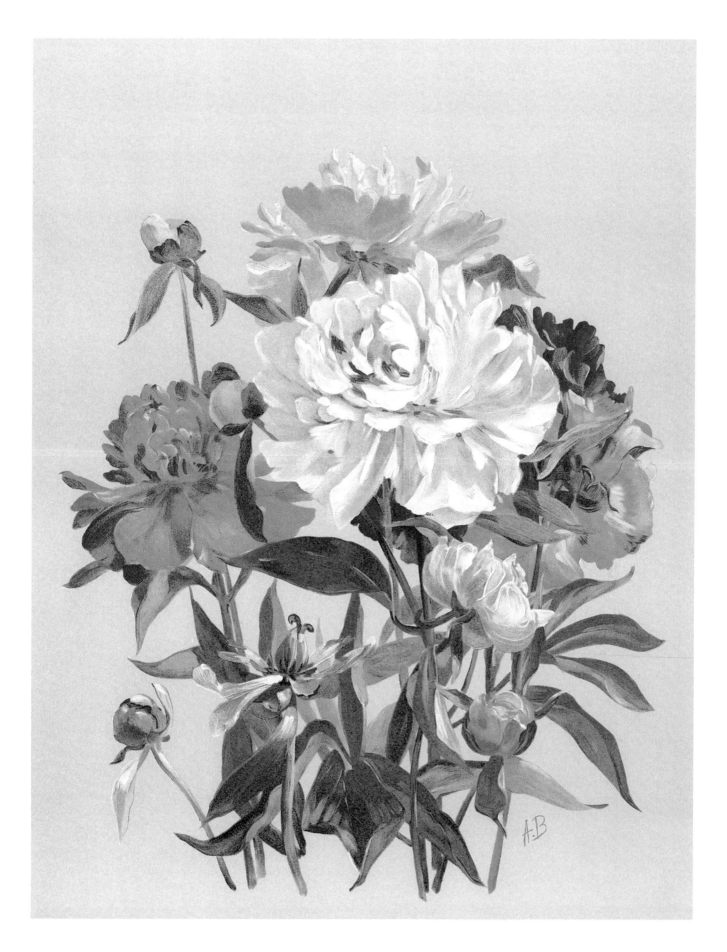

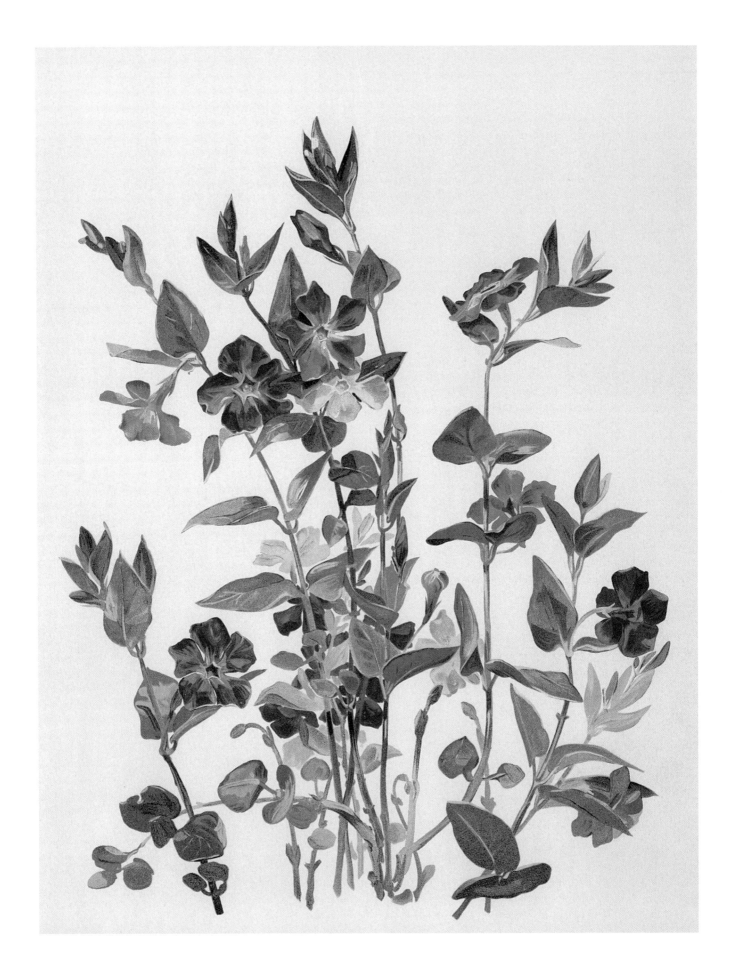

88 Periwinkle

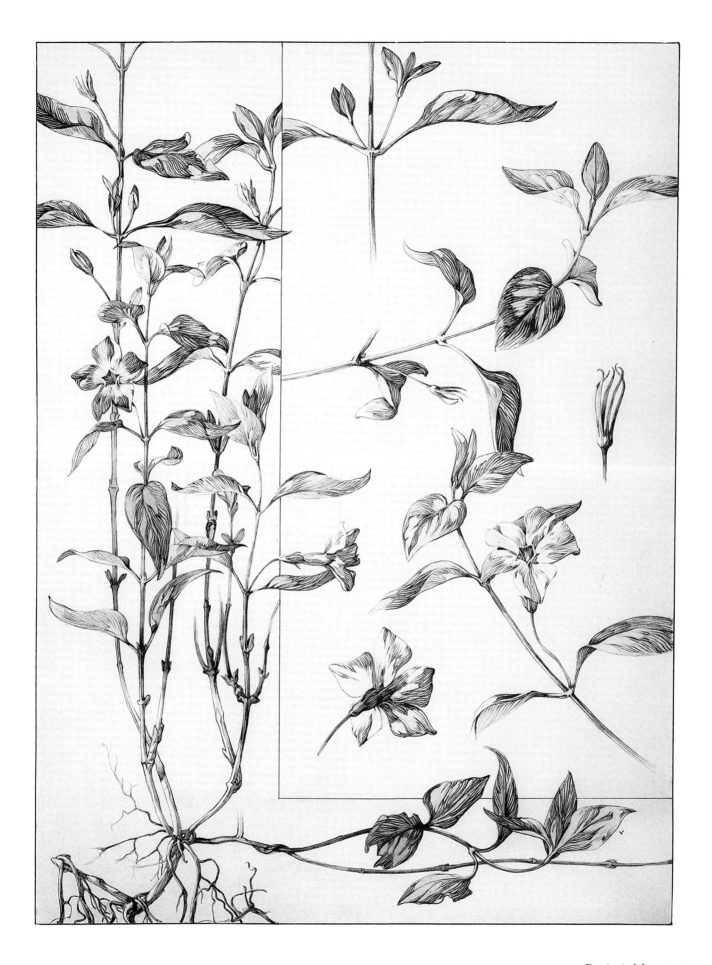

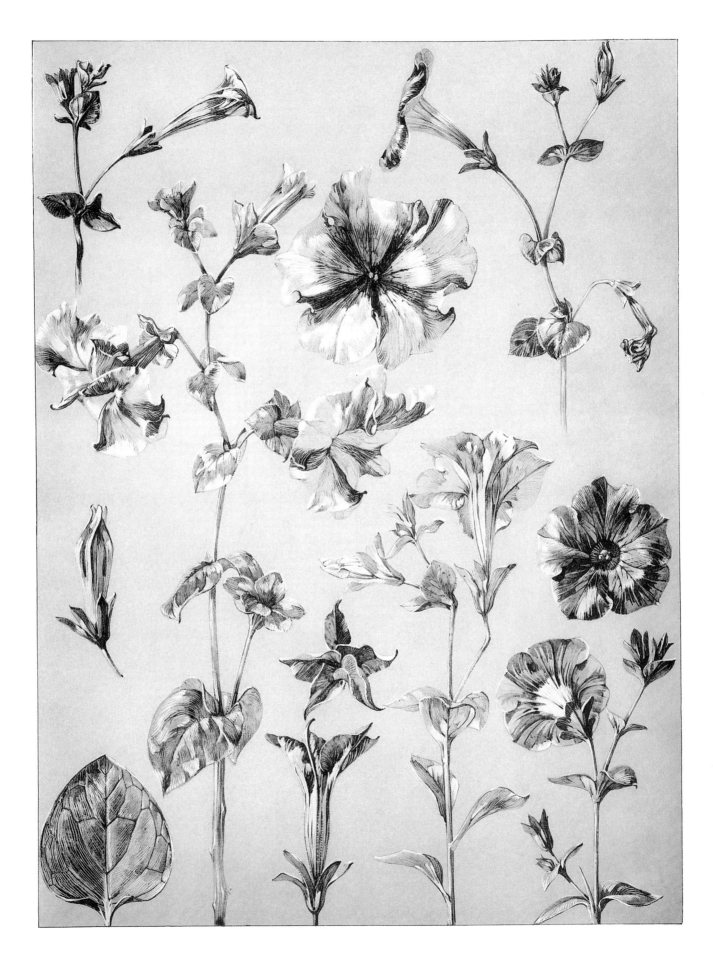

90 Petunia

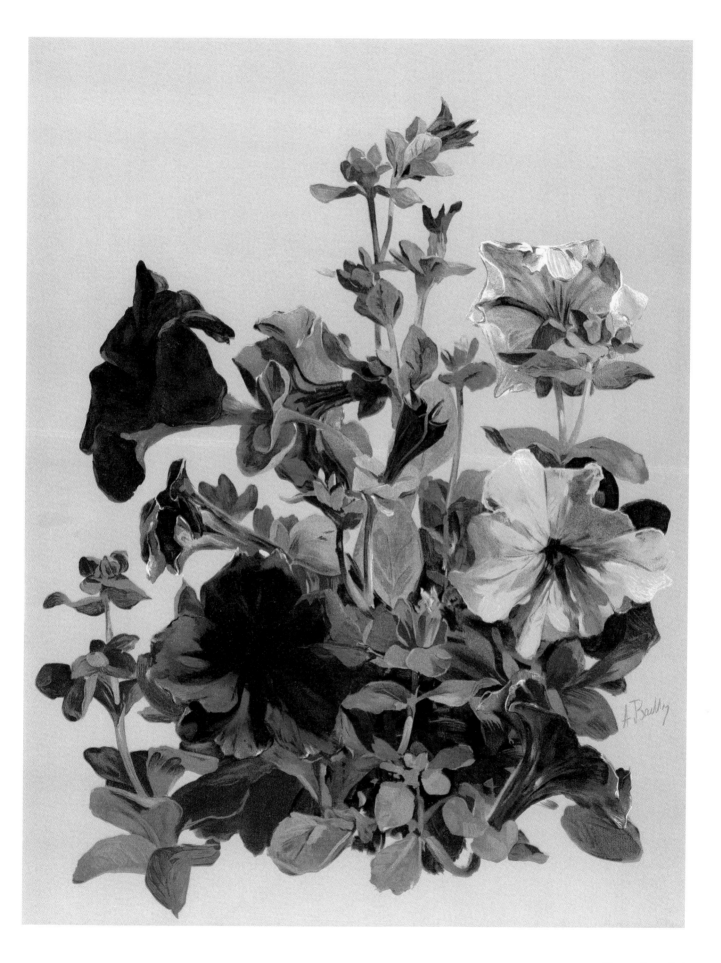

A. Bailly

Petunia 91

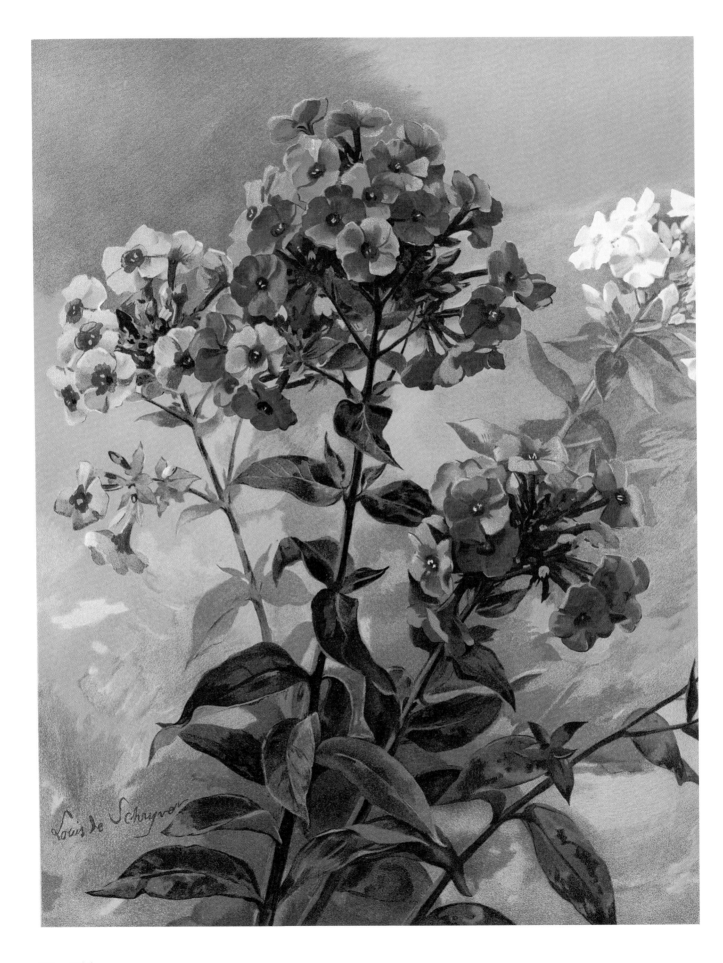

92 Phlox

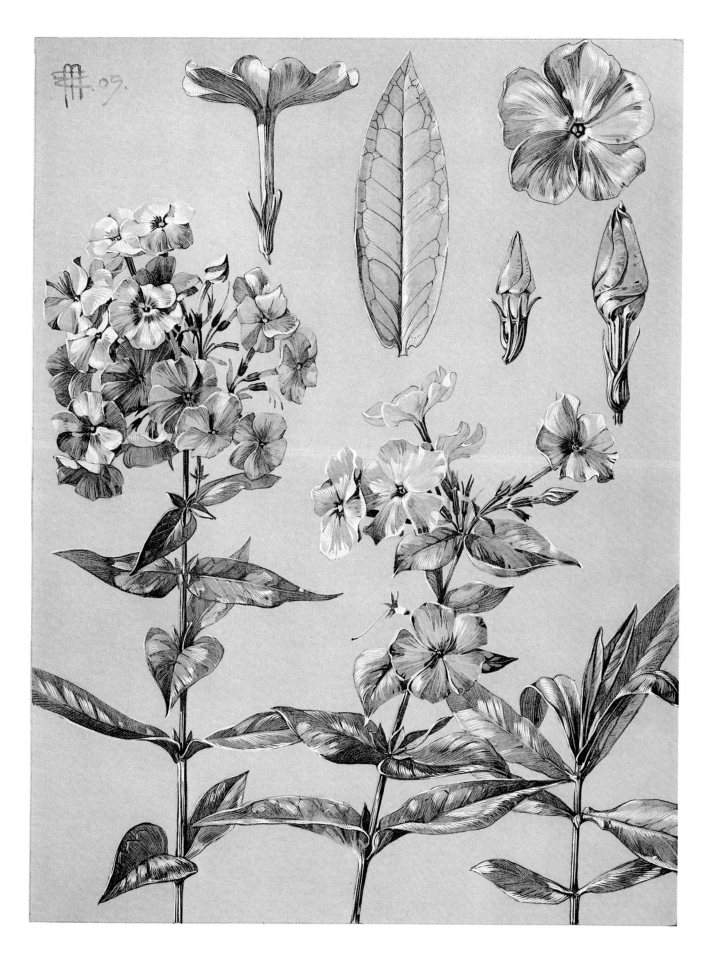

Phlox 93

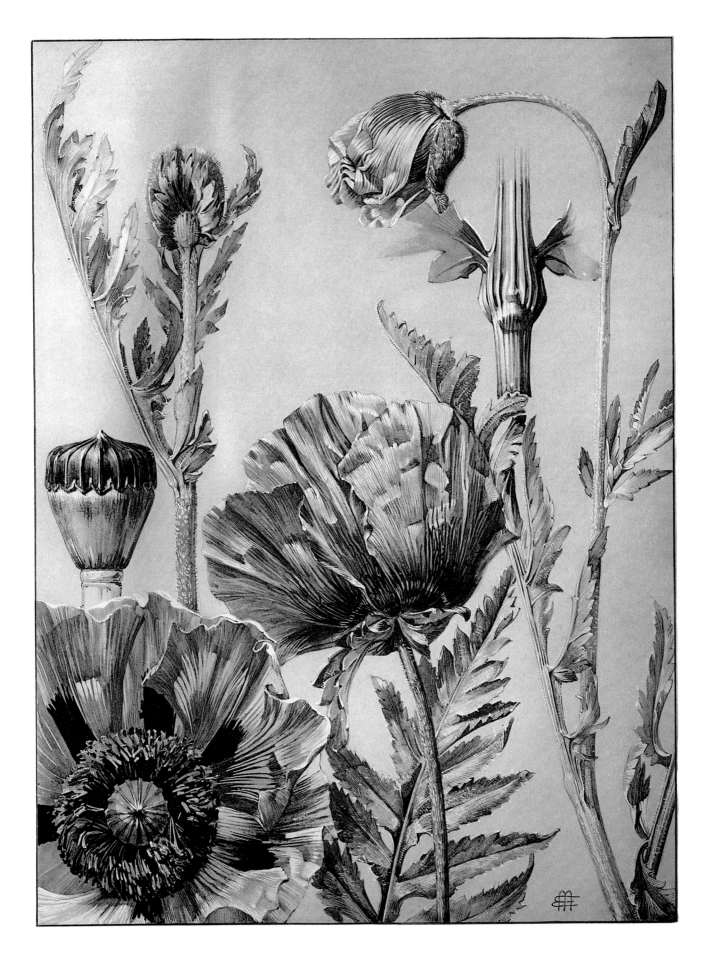

94 Poppy

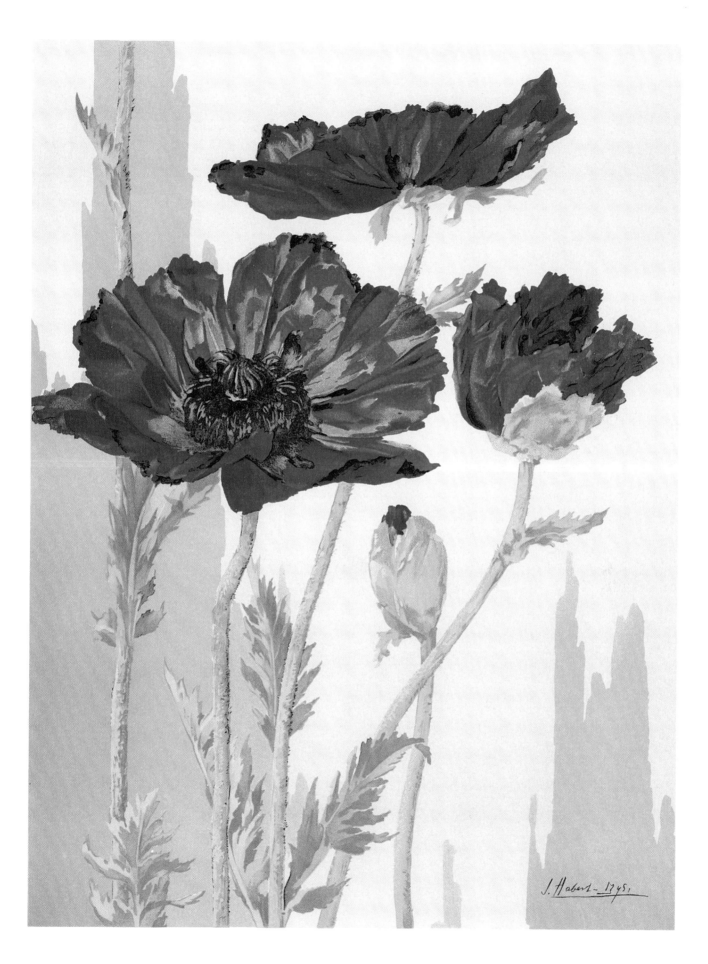

J. Habert — 1945,

Poppy 95

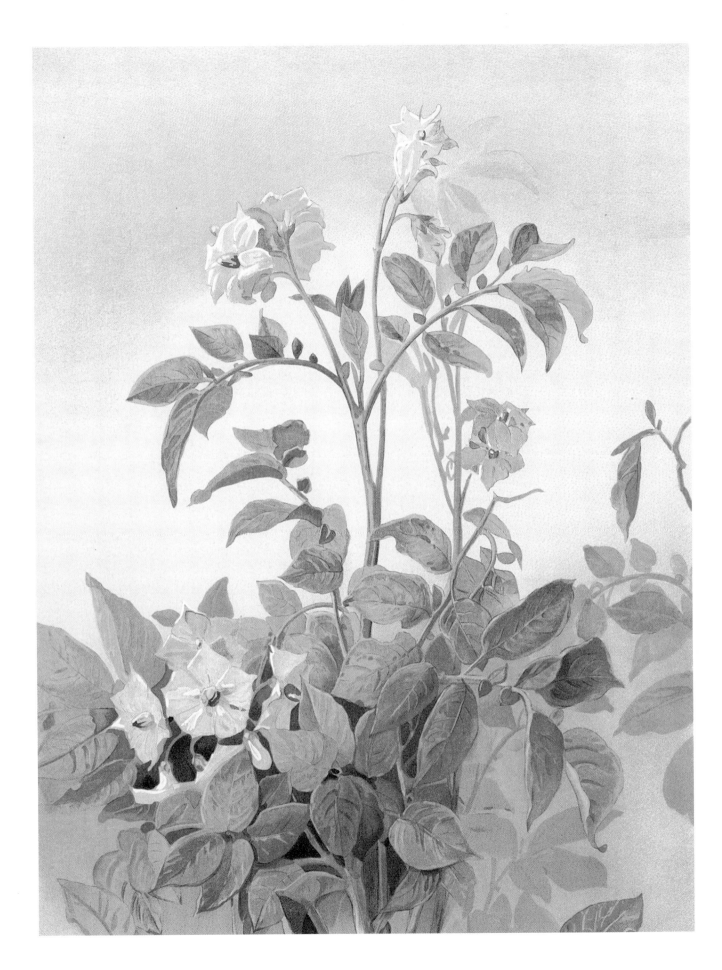

96 Potato

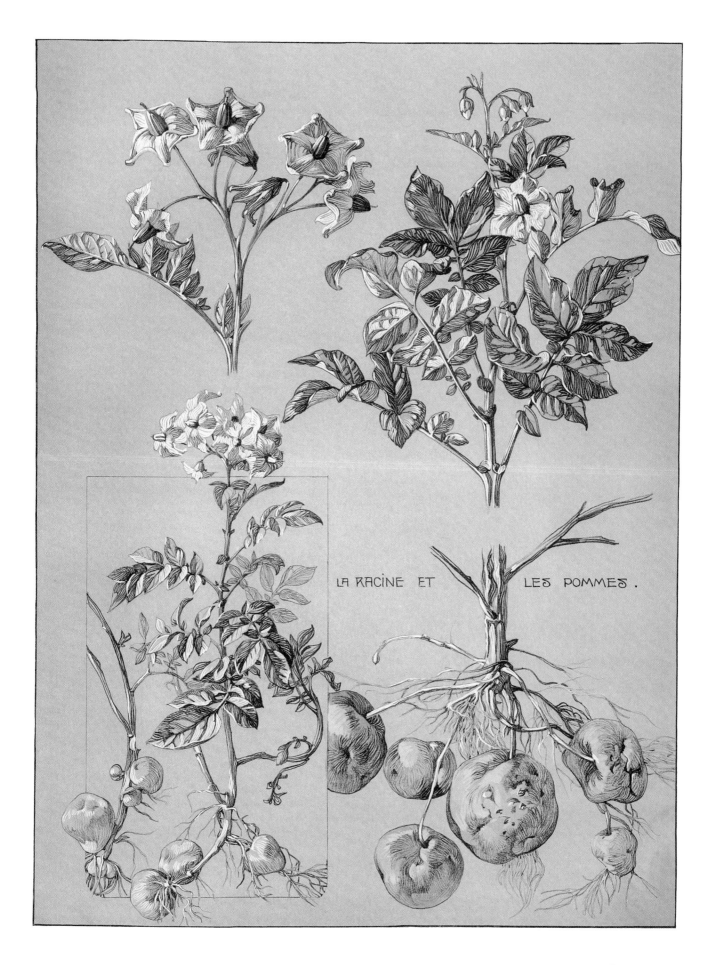

LA RACINE ET LES POMMES.

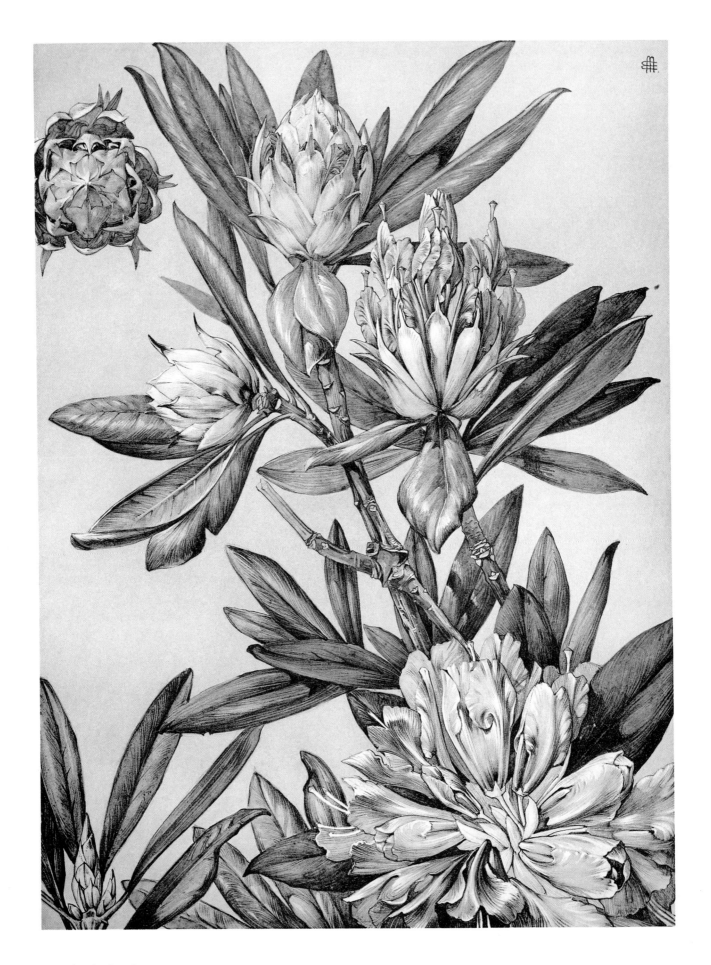

98 Rhododendron

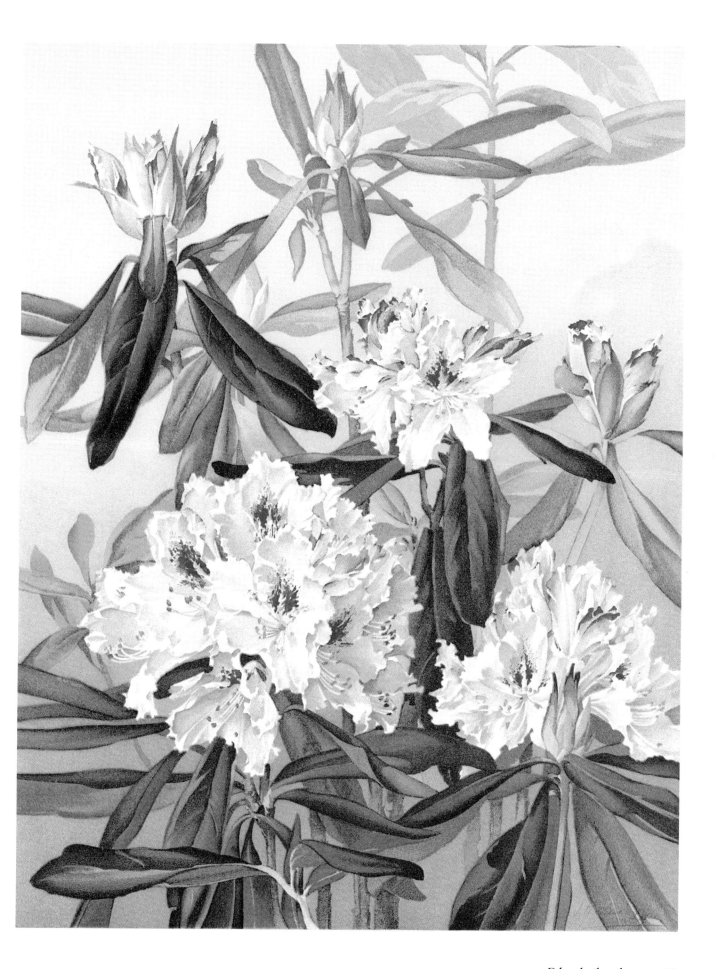

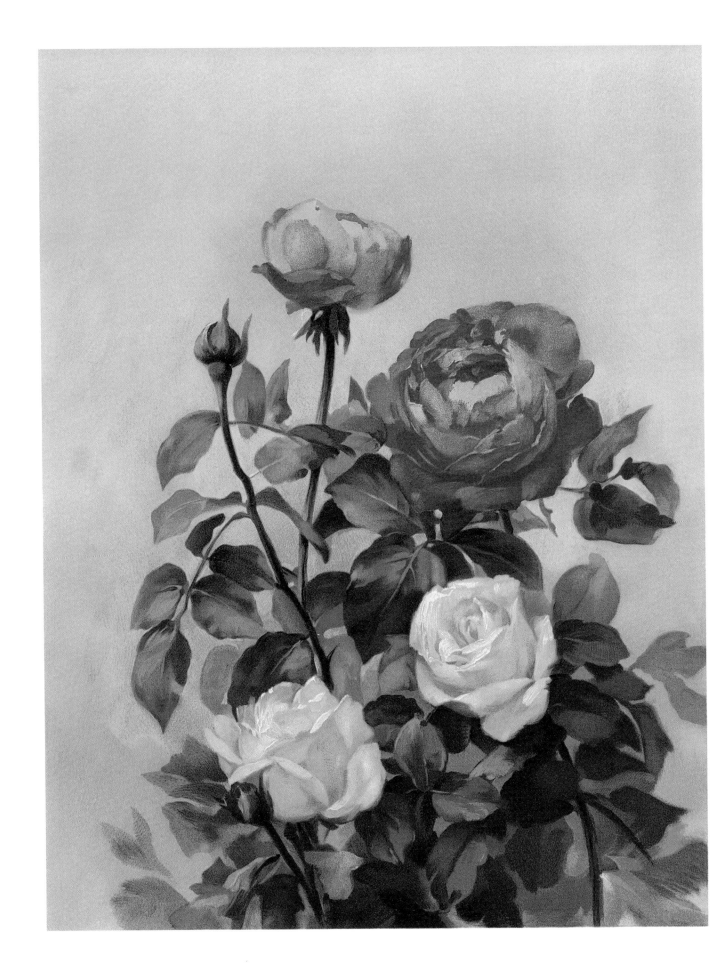

100 Rose

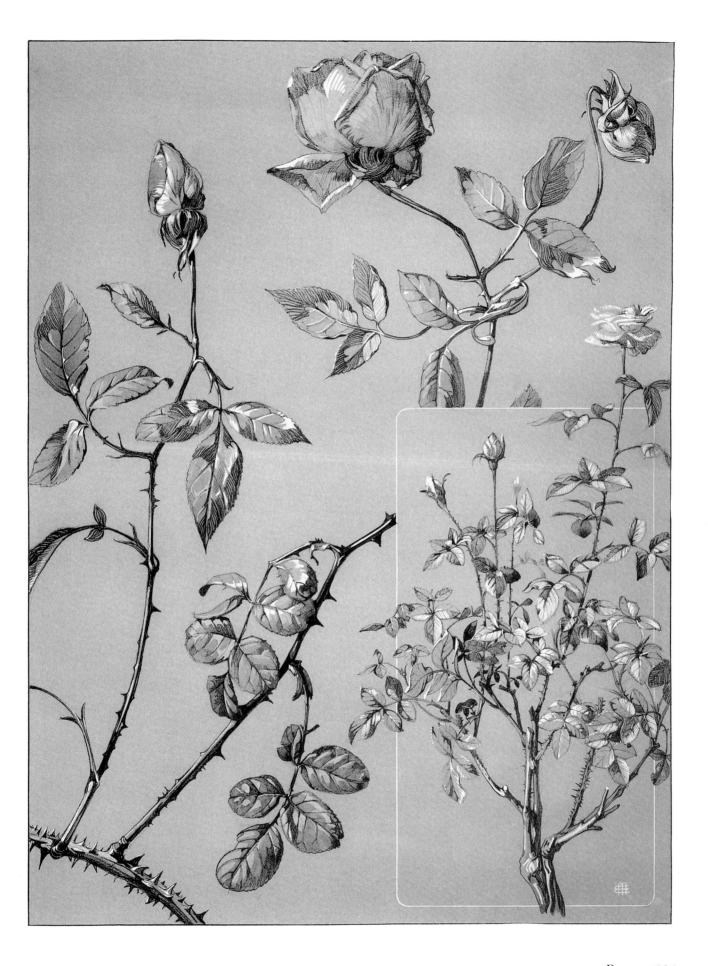

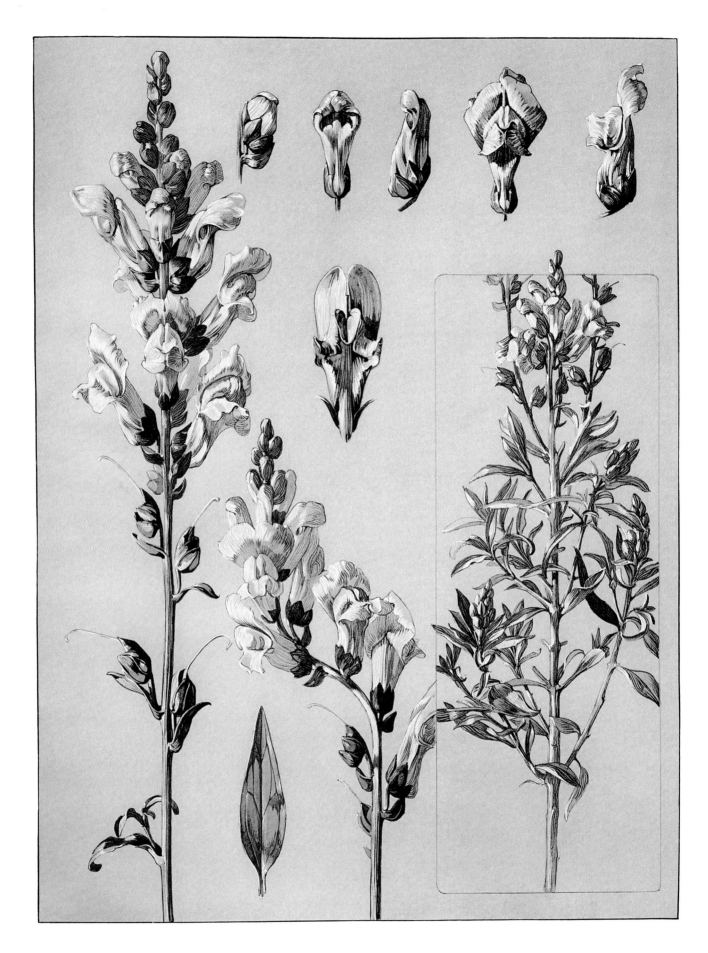

102 Snapdragon

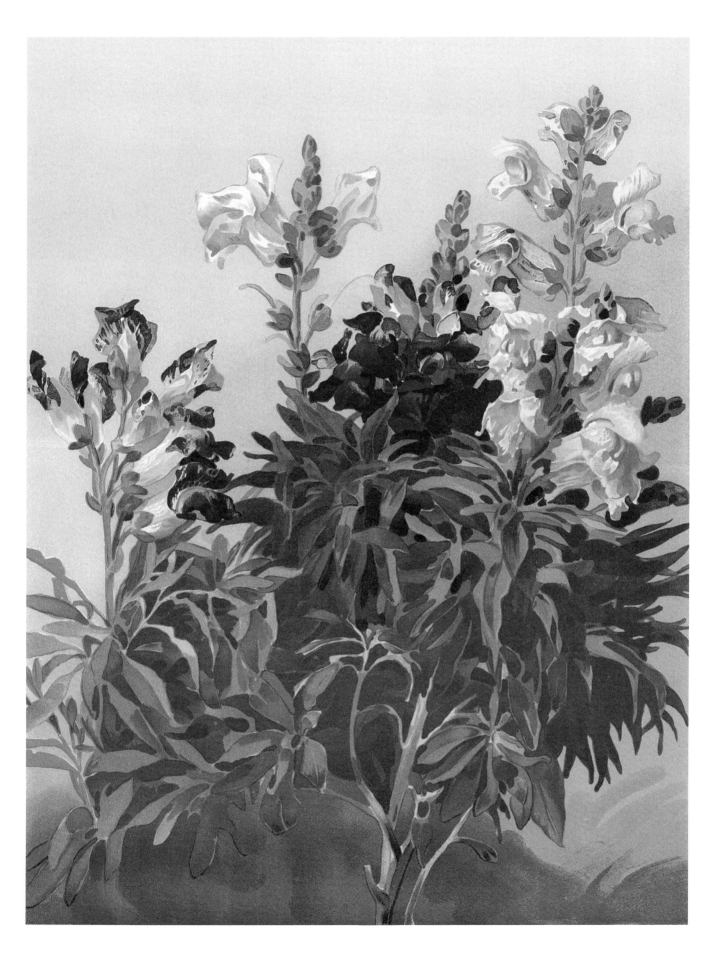

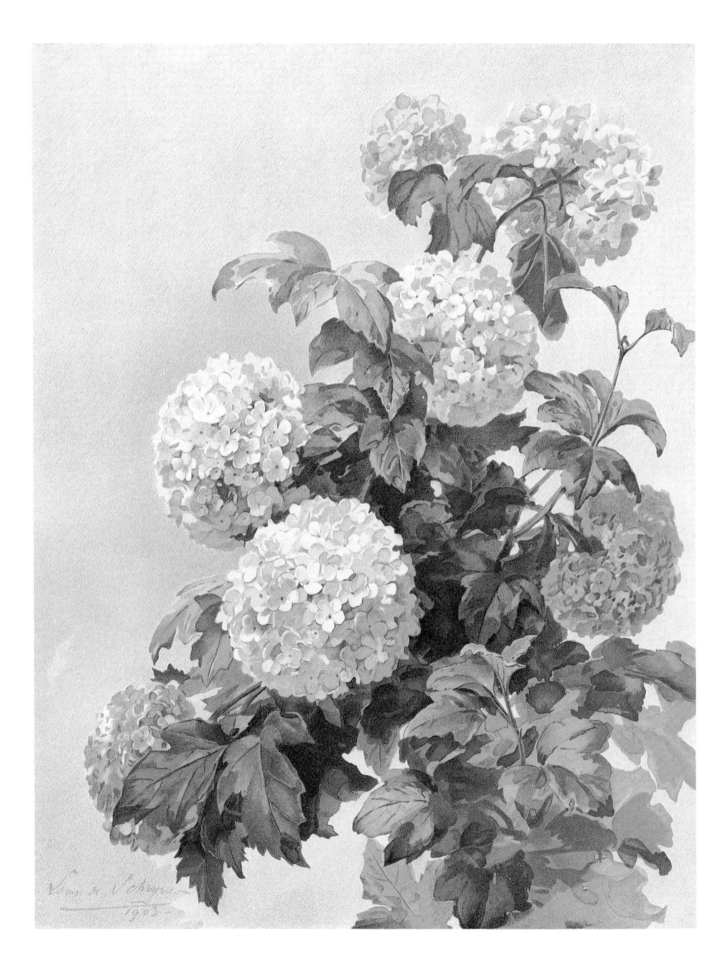

104 Snowball or guelder-rose

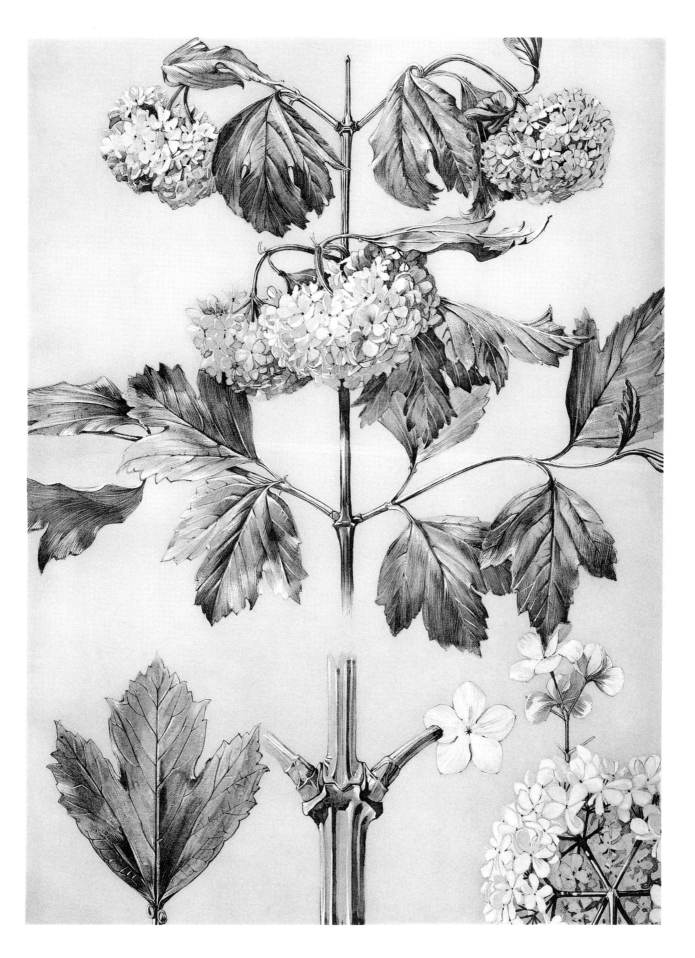

Snowball or guelder-rose 105

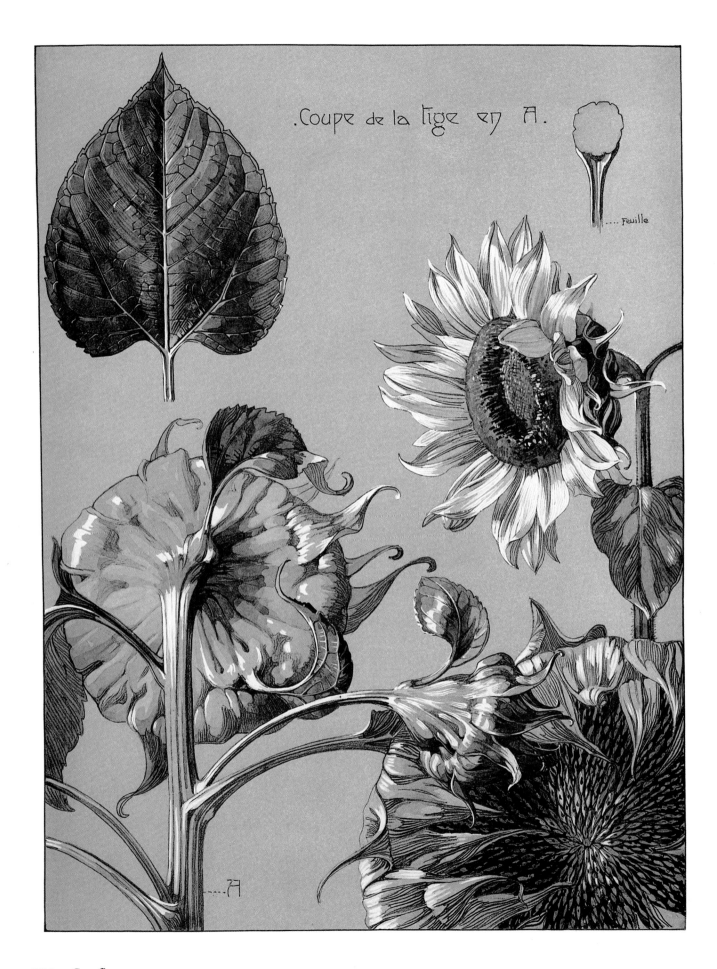

.Coupe de la tige en A.

.... Feuille

106 Sunflower

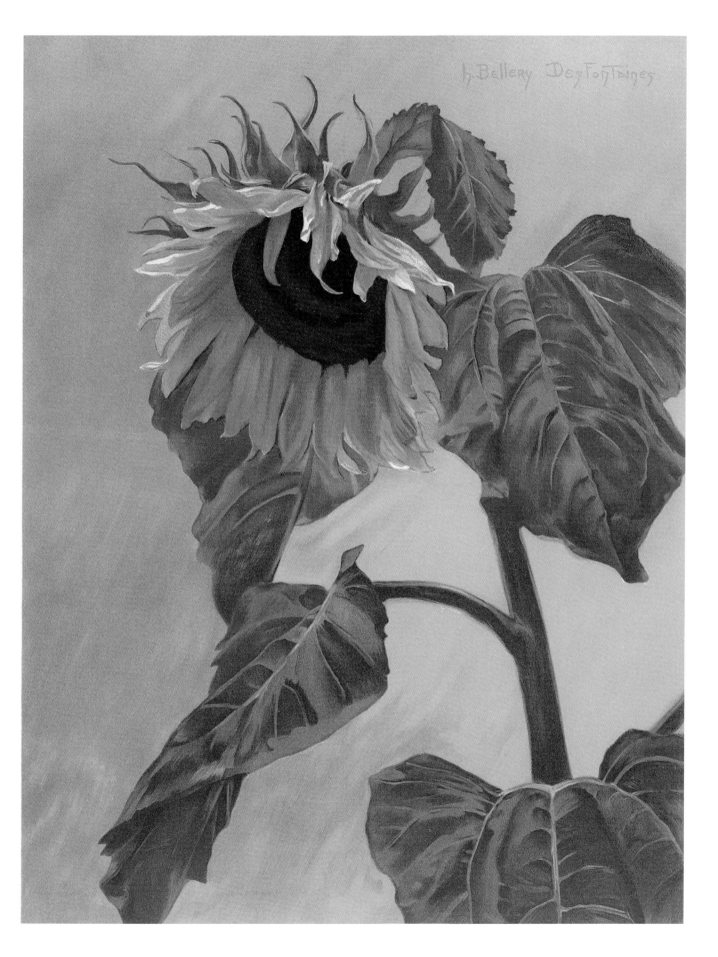

Sunflower 107

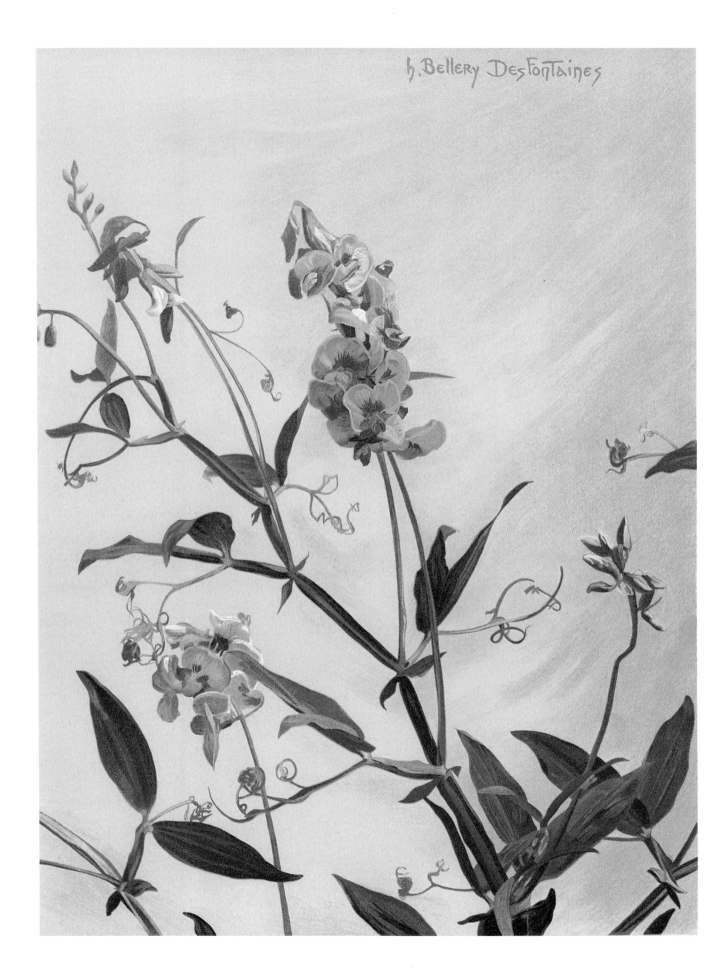

h.Bellery DesFonTaines

108 Sweet pea

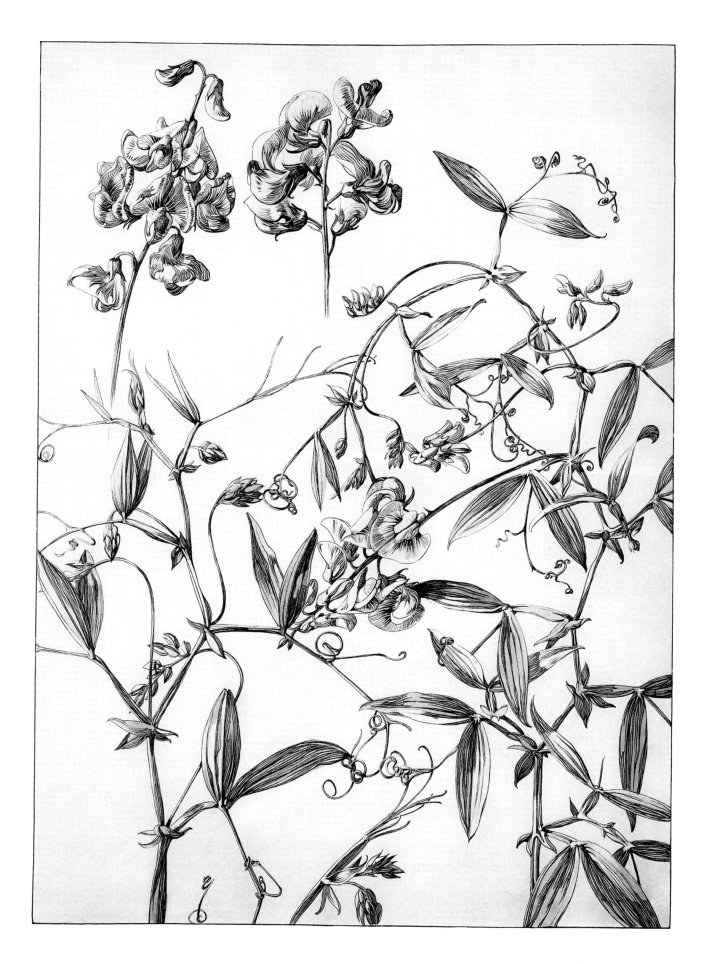

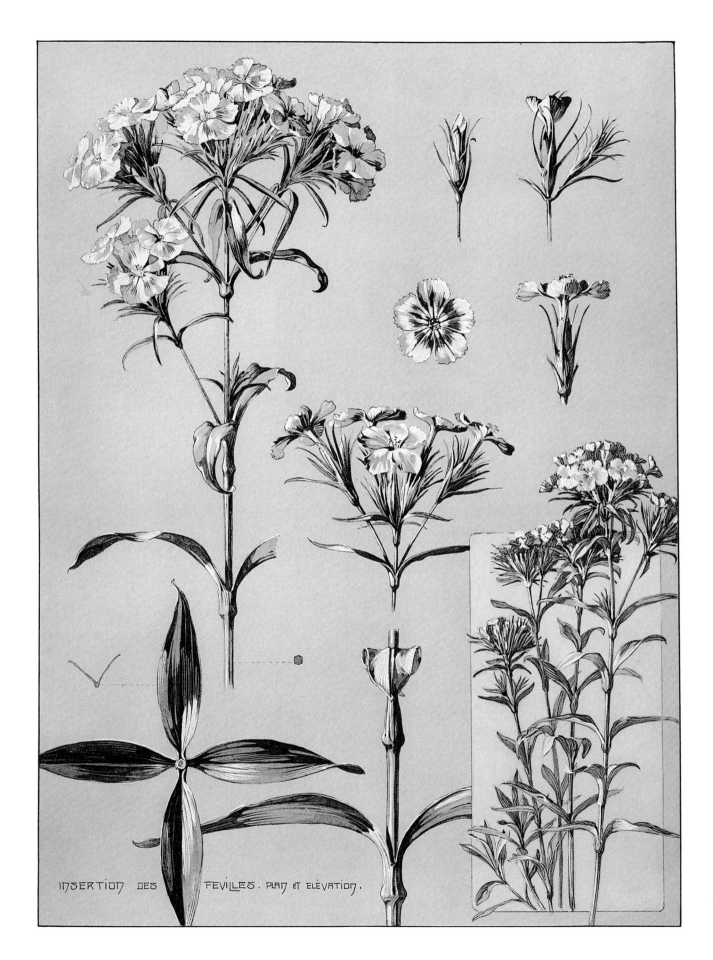

INSERTION DES FEVILLES. PLAN ET ELEVATION.

110 Sweet William

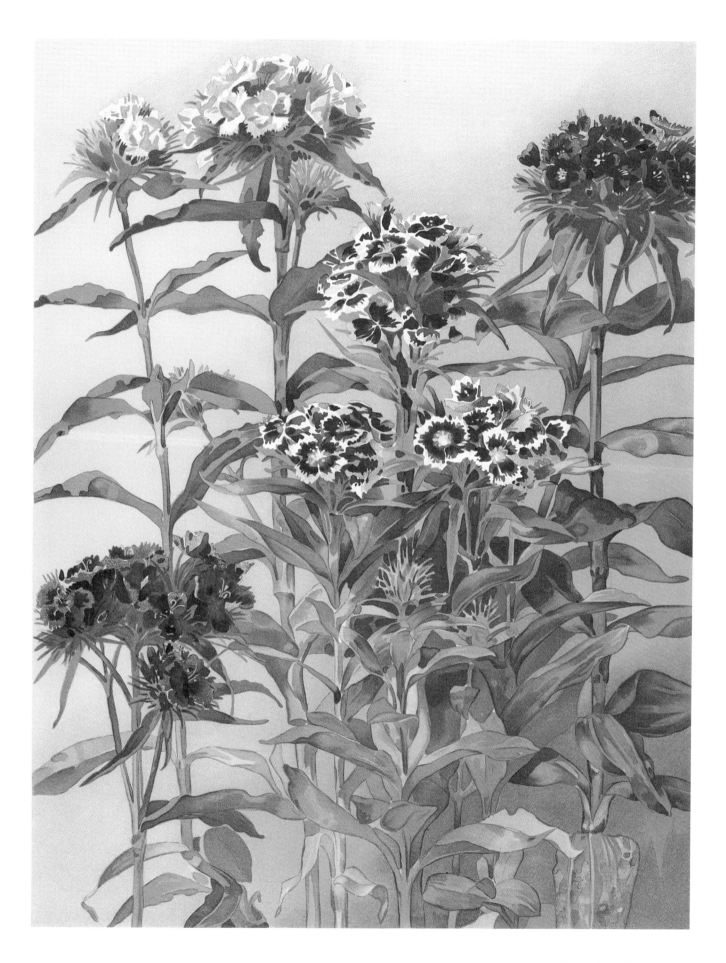

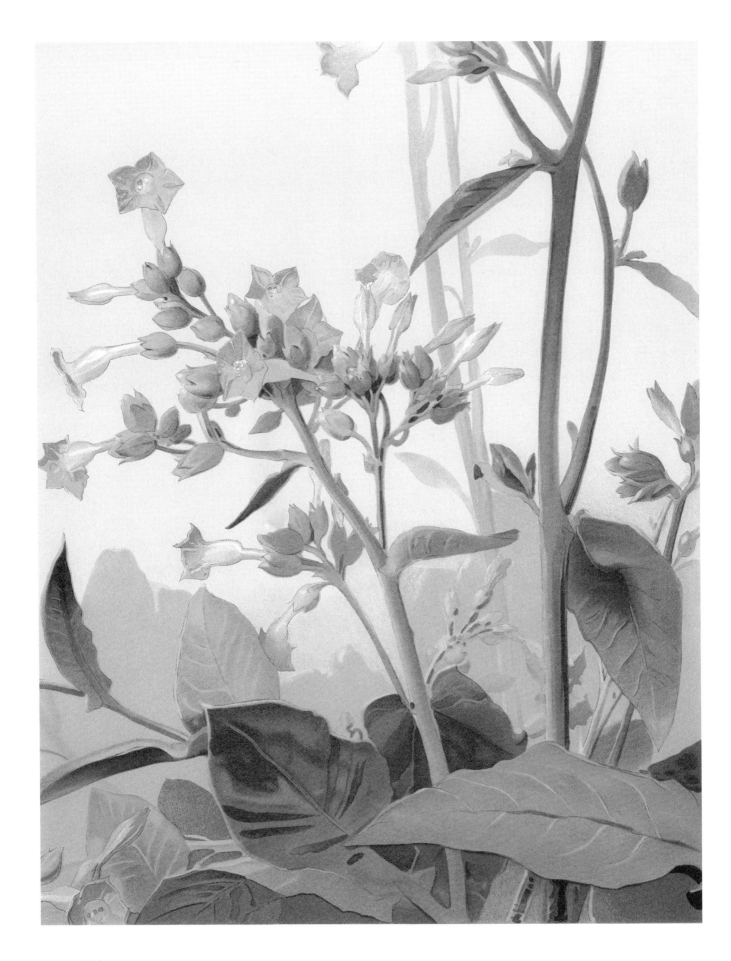

112 Tobacco

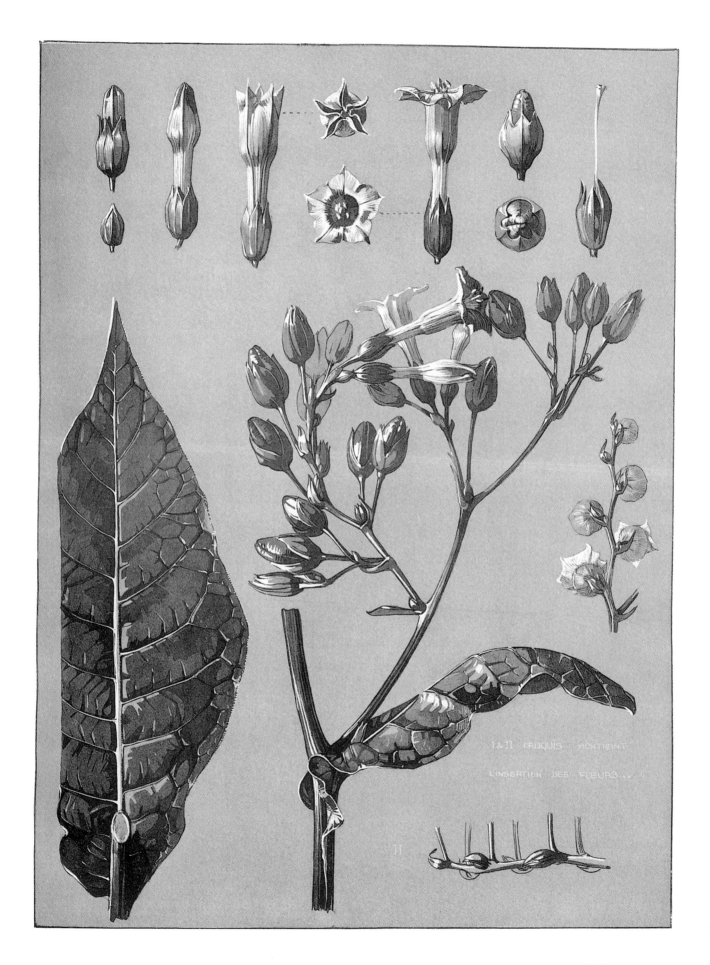

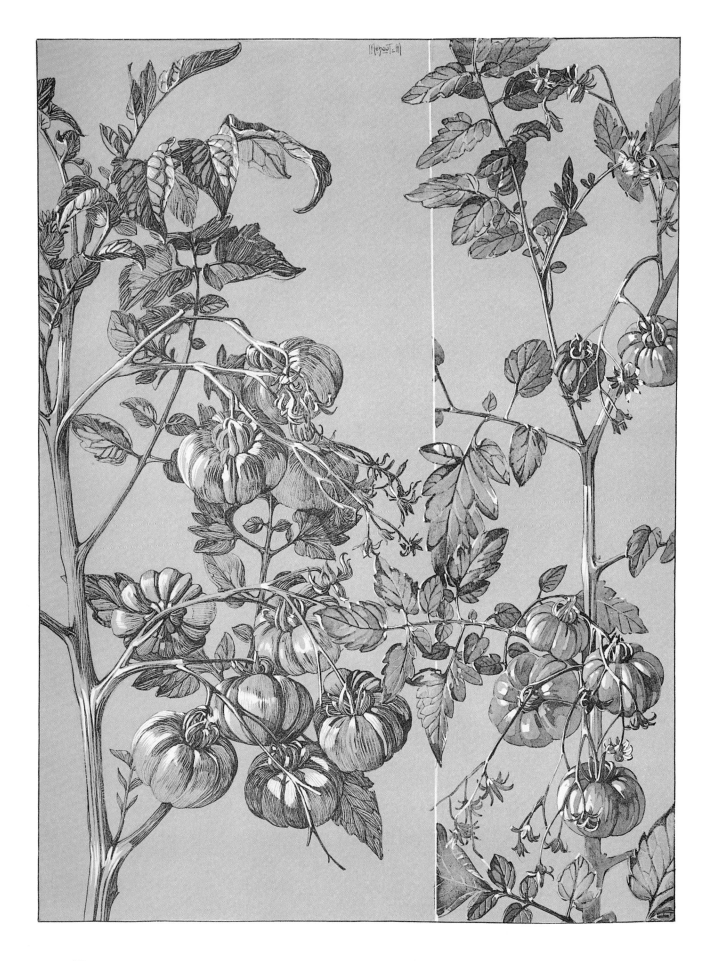

114 Tomato

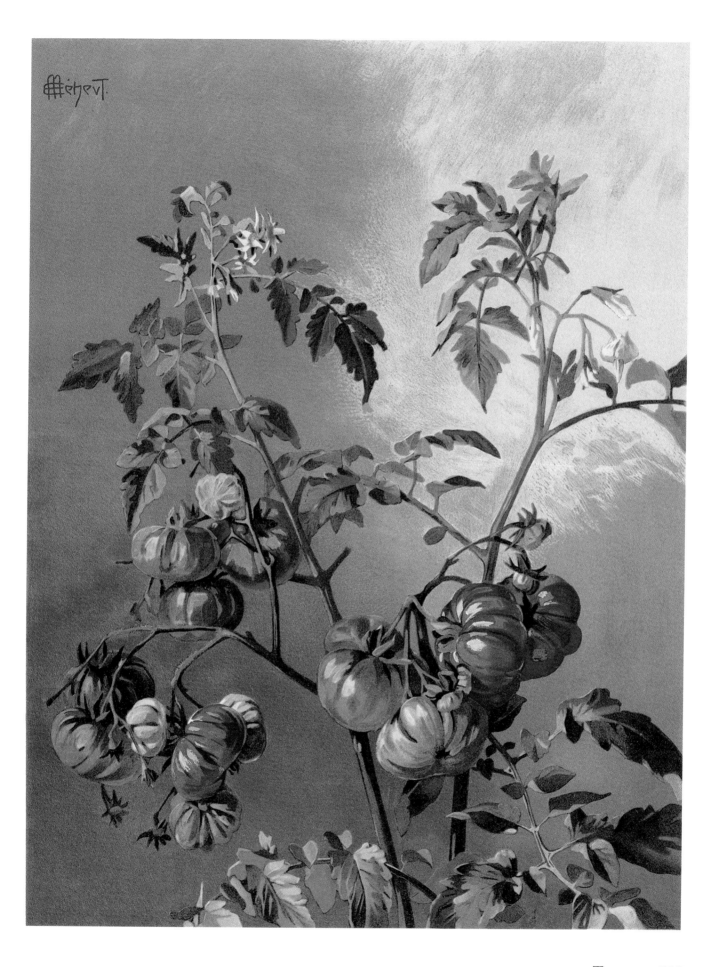

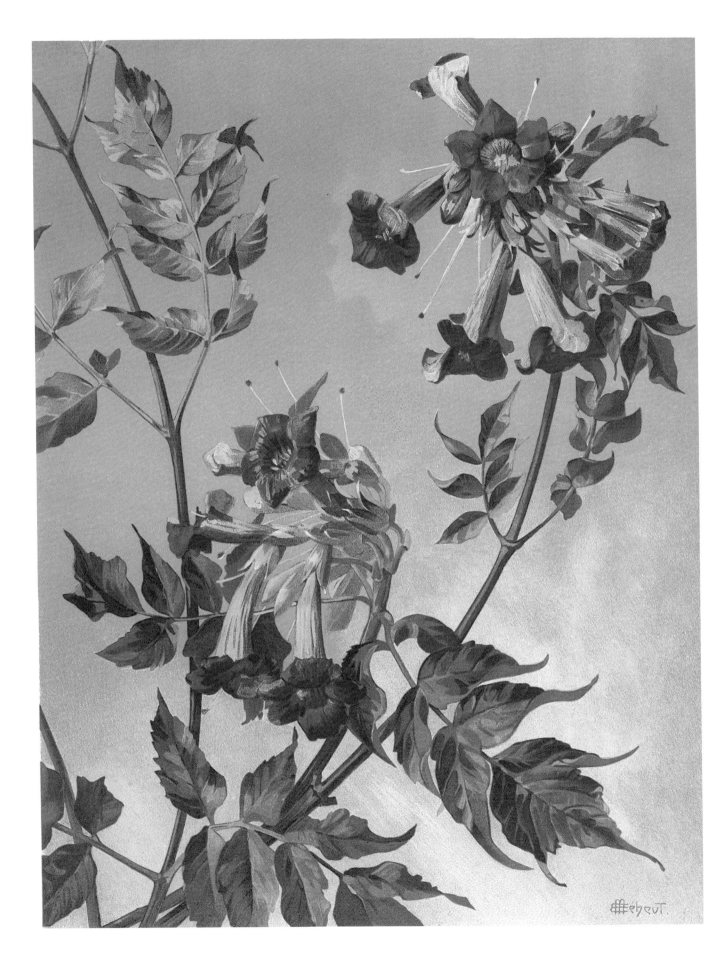

116 Trumpet creeper

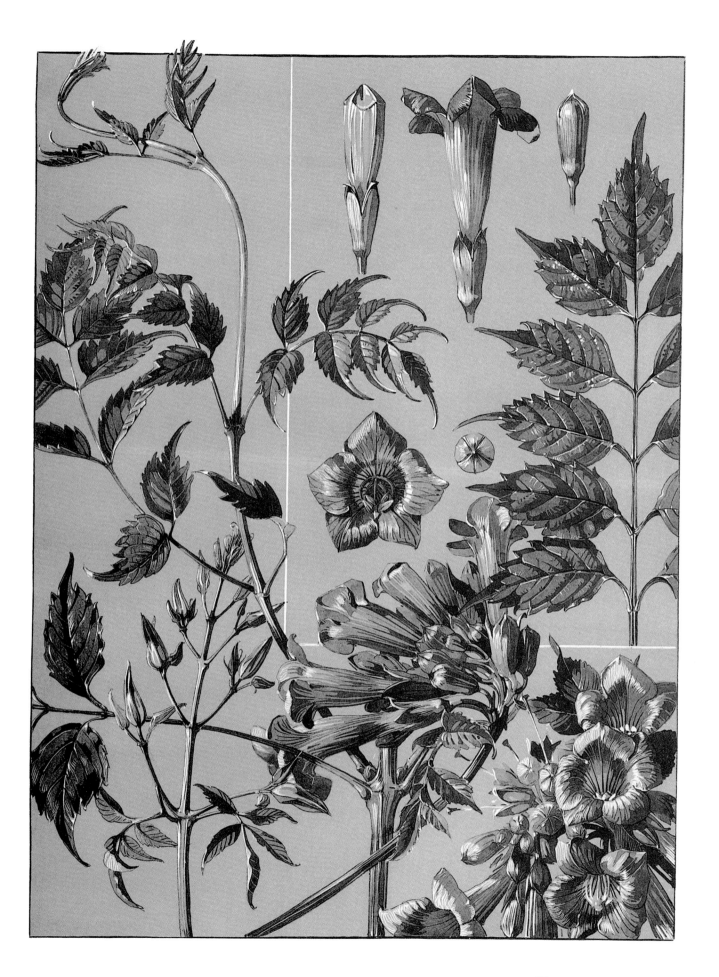

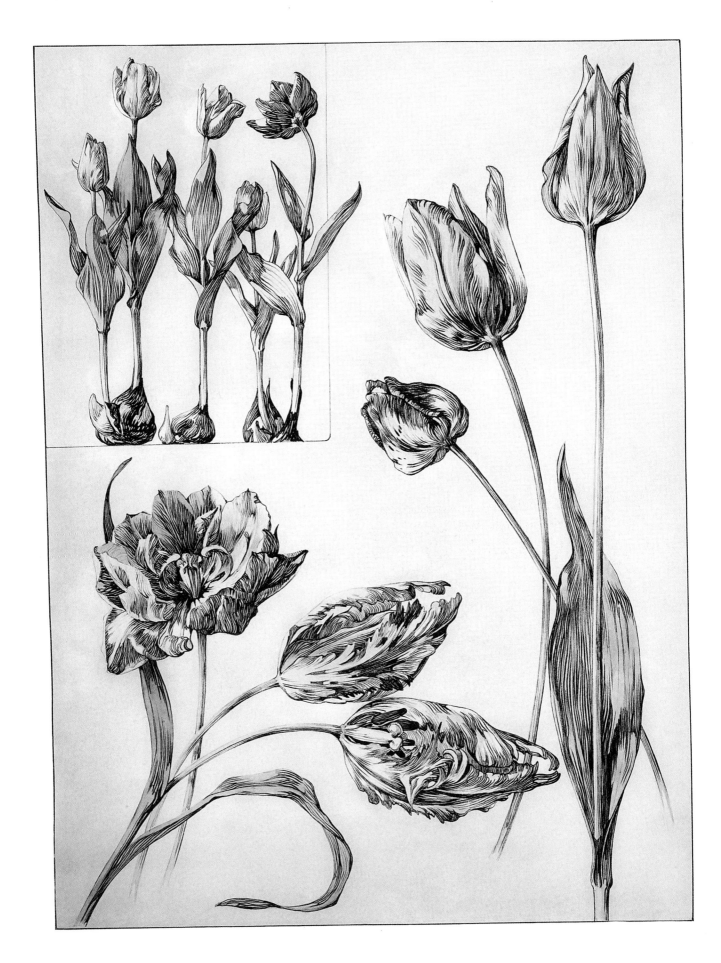

118 Tulip

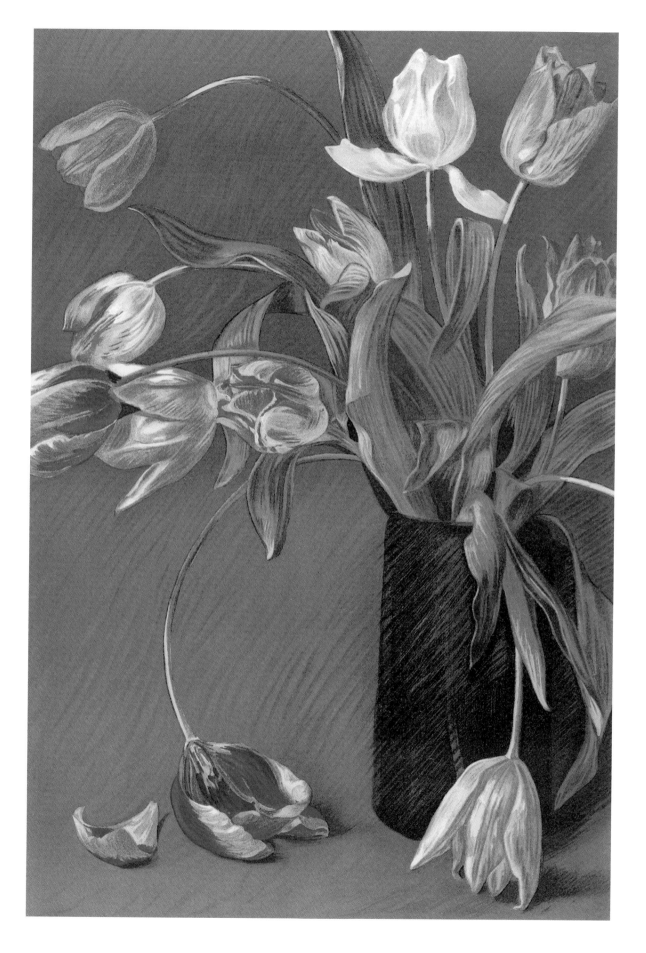

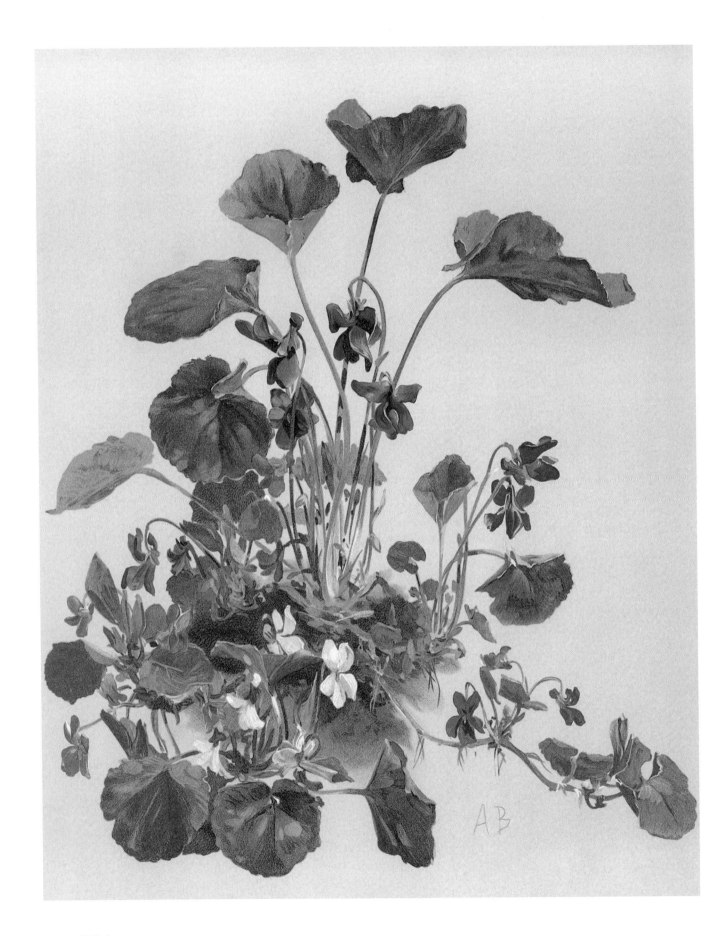

120 Violet

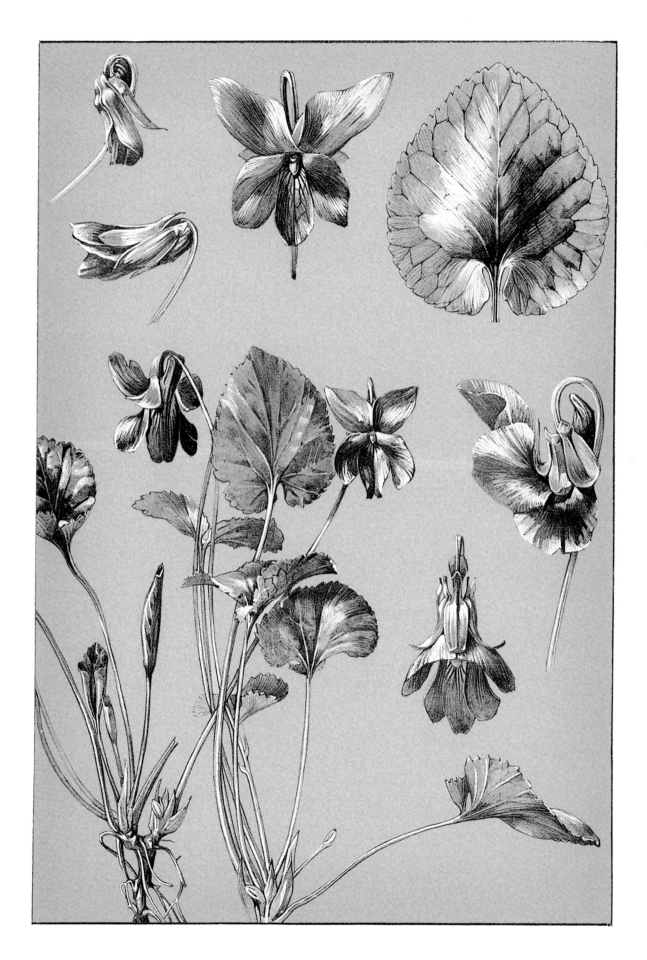